How to Create a HIGH PROFIT PHOTOGRAPHY BUSINESS

In Any Market

SECOND EDITION

James Williams

Amherst Media, Inc. ■ Buffalo, NY

DEDICATION

My two children, Lisa and James, have made me so proud. It is to them that I dedicate this book.

Published by:
Amherst Media, Inc.
P.O. Box 586
Buffalo, N.Y. 14226
Fax: 716-874-4508
www.AmherstMedia.com

Publisher: Craig Alesse
Senior Editor/Production Manager: Michelle Perkins
Assistant Editor: Barbara A. Lynch-Johnt
Editorial assistance provided by Chris Gallant, Sally Jarzab, and John S. Loder

ISBN-13: 978-1-60895-266-3
Library of Congress Control Number: 2010904521

Printed in Korea.
10 9 8 7 6 5 4 3 2 1

Notice of Disclaimer: The information contained in this book is based on the author's experience and opinions. The author and publisher will not be held liable for the use or misuse of the information in this book.

Check out Amherst Media's blogs at: http://portrait-photographer.blogspot.com/
http://weddingphotographer-amherstmedia.blogspot.com/

CONTENTS

ABOUT THE AUTHOR

James Williams has been involved with photography for more than twenty-five years. Today, James and his wife Cathy operate a successful wedding, family, and high school senior portrait business. They also photograph some sports leagues and hold high school senior contracts. James is certified through the Professional Photographers of America and the Professional Photographers of Ohio. In 2001, he was inducted into the prestigious Society of Professional Photographers of Ohio. Membership is by invitation only. In 2002, he was elected president of the Society of Northern Ohio Professional Photographers. Based in Cleveland, this organization has over seventy-five members. In February of 2004, James earned the Accolade of Photographic Mastery from Wedding Portrait Photographers International. He is one of only eight Ohio photographers to hold this degree. In 2005, James completed the requirements for his Craftsman degree from the Professional Photographers of America and also completed the requirements for the Accolade of Outstanding Photographic Achievement from Wedding Portrait Photographers International. Williams lectures several times a year at various photography organizations' events and presents lighting, posing, and marketing seminars at his studio.

ACKNOWLEDGMENTS

Ask anyone who is running a successful business of any kind and they will all tell you they could not have done it on their own. Having talented people in your corner who share your ideas and vision will definitely make a difference. There have been many people who have contributed to the success of our studio. First, without my wife's support and organizational skills, I would have been out of business a long time ago. She has had a major impact on our success. There have been and continue to be countless people that I can call on whenever a problem occurs. Over twenty-five years ago when I first got interested in this business, I enrolled in a photography class at the local vocational school. The instructor at the school was Tom Songer, a very talented Master Photographer who taught me beautiful lighting and posing which I still use today. Unfortunately, Tom died at a very young age from, of all things, a bee sting. John Shrilla, who used to work for Photogenic and now has his own company, helped me with the layout and lighting I use today in my camera room. Little did I know at that time the value of all this information. Ladd Scavnicky has helped me with wedding posing. Ron Kotar has shared his ideas on being more profitable with sports and dance packages and has helped me make the transition to digital. Also, I want to thank Patrick Rice, who has helped me with print competition and wedding posing and also recommended me to Mr. Craig Alesse as a prospective Amherst Media author. You are reading that book now. Thank you, Pat, for putting your name and reputation on the line for me. Also, I would like to thank Robert Williams from Tallmadge, Ohio, for suggesting my name for membership into the Ohio Society of Professional Photographers. I am both honored and humbled to be a member of the Ohio Society. Bob, it's people like you who make the society what it is: a very select group of some of the finest photographers in the country. Finally, I would like to thank Rex Fee for his superior sports candids that appear in this book. Rex has been shooting sports candids for me for over twelve years. His sports action photos are in many high school yearbooks in this area. He is someone I can always count on. Thanks, Rex, for all your help over the years.

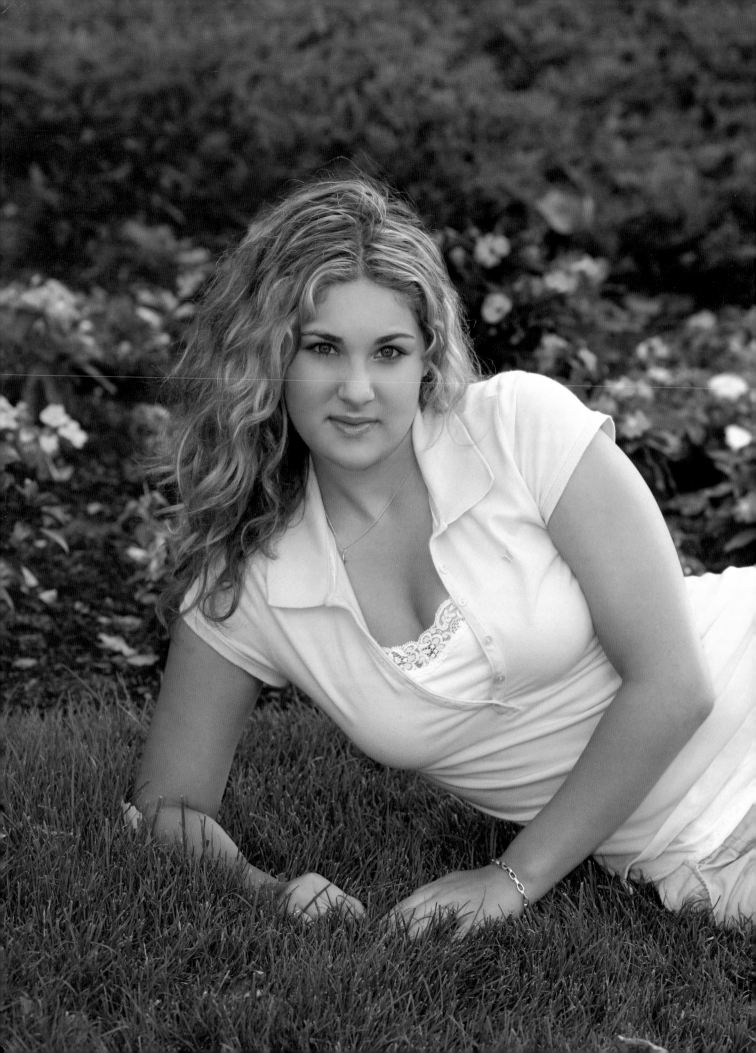

INTRODUCTION

I think it's fair to say that running a photography business is not an easy way to make a living. First of all, anyone can go out and buy a camera, run an ad in the local newspaper, and claim to be a professional photographer. You see, in the United States, you don't need a license to work as a professional photographer. As long as you can create images that customers are willing to pay money for, you're in business. It's sad to say, but according to the Professional Photographers of America, the average salary for a professional photographer in this country is approximately $25,000. There are some photographers who don't make a profit at all, and many others depend on their spouse's employment for health care benefits and additional salary for the household.

In this text, I am going to show you, step by step, how you can rise above all of the struggling part- and full-time photographers. You can earn a very comfortable living in this business, but it won't happen by just taking nice pictures, and it's not going to happen overnight. I'm not going to make any wild claims about being one of the most profitable studios in the country or tell my readers to just learn all my "secrets" and watch the money roll in. Exaggerated claims only confuse and mislead. What you will find in these pages is insight into the strategies that have worked for

There's much more to attaining success as a professional photographer than just taking pretty pictures.

our studio over the past twenty-five years. One of the keys to our success has been the array of photographic services that we offer and the level of service we provide. In my opinion, to be successful in a small-town photography business, diversification is almost essential. In the following pages, you will learn everything that has worked for us, as well as all the things that have not and why. After reading this book, you will be well on your way to operating a successful photography studio in a small town or a big city.

Offering a diversified list of services is critical to the success of most studios.

1. BEGIN WITH THE END IN MIND

When you are starting out in this business, it is best to do so with the end in mind. You must visualize the kind of business you want to have years from now and make daily decisions that will help you to achieve your goal.

SET SHORT- AND LONG-RANGE GOALS

Talk to any business owner and he or she will tell you how important setting short- and long-range goals are for the success of your business. Short-range goals are daily or weekly goals, and long-range goals are those you want to accomplish in one to five years, or even longer. It is best to have them written down. Also, be sure that they are difficult but attainable. You should share your goals and vision with everyone who has anything to do with your business. The employees you hire will have an impact on whether your goals are achieved. You must surround yourself with successful people. You cannot make it happen by yourself. When I started out in the photography business, my short-range goal was to create the best images I possibly could and provide my clients with the best-possible service. One thing is certain: poor service will get you into more trouble with your clients than average to poor photography.

WHAT KIND OF CLIENTS DO YOU WANT TO ATTRACT?

Do you want to photograph weddings at the fire hall, or would you prefer working with a bride and groom who will be having their reception at an opulent country club? The first impression you create for your clients will send them a strong message about you and your work and will help them determine whether you are the right photographer for their special day.

Let's assume that a bride-to-be has called and made an appointment to visit your studio to learn more about your wedding coverage. What kind of impression does your studio project?

First impressions count. A prospective client will form an impression of your studio from the minute she dials your number. Does your office staff answer the phone in a professional manner? Great phone skills are essential, and if an individual with bad phone manners gives your prospective client a poor impression, she may lose interest in checking out your studio.

REACHING YOUR GOALS

Starting with the end in mind is one of many concepts I learned in 1997 when I attended a Steven Covey seminar. For those of you who have never heard of him, Mr. Covey is an extremely successful lecturer and writer. His concepts and ideas are used throughout corporate America. Whether you are running General Motors or a small photography studio, certain business principles apply. I highly recommend that you read his book, *The Seven Habits of Highly Successful People* (Free Press, 2004).

Does your studio have curb appeal? In other words, does your business look good from the curb or street? Is the front door clean and inviting? Is the sidewalk maintained, and is the property accented with landscaping and flowers that lead visitors to the entrance? Does the studio door have an expensive feel when you open it?

The way you present yourself has an impact on your business. Are you dressed like a $500 or a $5000 photographer? If you want to make money in this business, be sure to dress like you are already earning it.

Your studio should look like a fine jewelry store. Everything should be very neat and clean, particularly the bathroom. I have been to studios that are beautiful on the inside, but they are few and far between. If you do not have the time or desire to keep your studio clean, hire a cleaning service to come in at least once a week to do it for you. There is simply no excuse for not keeping the interior of your business sparkling clean.

My studio is not large, but I have worked to make it as attractive as possible. We are very fussy about the interior of our business. After each session, the dressing room carpet is vacuumed and the mirrors are cleaned.

LEFT—A high camera angle was used for this image. **RIGHT**—High school seniors like the shadows created in this dramatic lighting approach. This lighting breaks every rule in the book. Images like this one have a lot of impact, and that is a quality that students love.

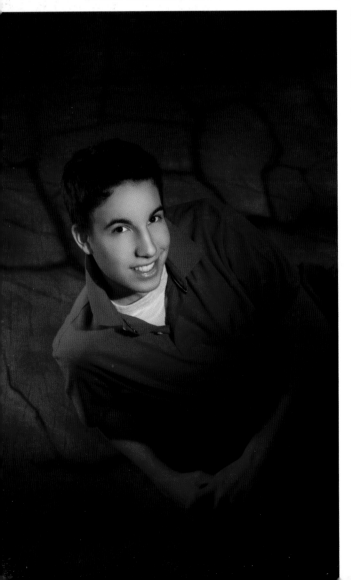
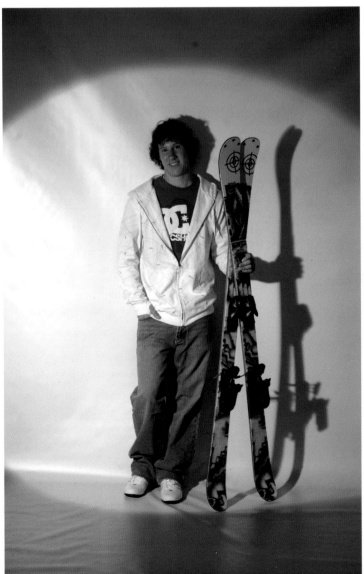

TOP—Close-ups are always popular with high school seniors. **BOTTOM**—Very controlled, dramatic lighting creates the impact for this image.

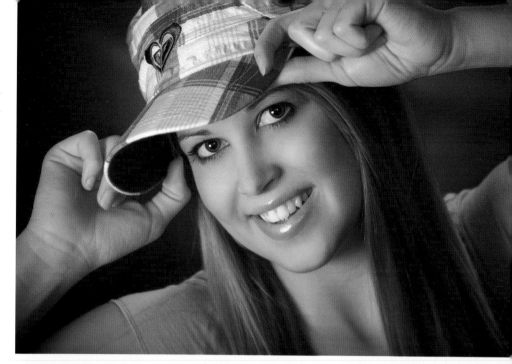

Finally, be sure that your advertising and marketing pieces also support the look you are trying to achieve inside of your studio doors. Price lists, stationery, brochures, and business cards should appear just as polished as your studio and your wardrobe.

Remember, in this business, we are selling "wants" not "needs." Every experience the individual has when she enters your studio must be positive if she is to part with her money.

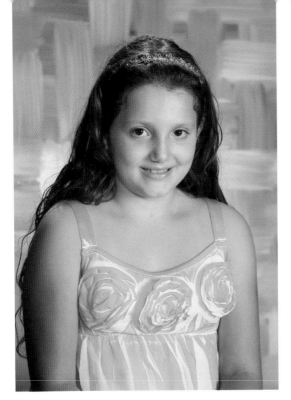

SUCCESS LEAVES CLUES

Why are some studios successful while others are just barely making payments on their lab account? Generally speaking, it has little to do with taking "nice pictures."

Many photographers think that all they have to do to improve their business is take better pictures. There are others who confuse being busy with being successful: they think that if they are busy, they must be making money. I don't know about you, but my success is based on the amount of money I keep, not on the amount of money I collect. More clients and more pictures does not equate to success. Fewer, higher-budget clients can help you reach your financial goals.

Take some time to visit area studios and gather clues about their performance. How is the telephone answered? What do you think of the décor of the studio? How are the employees dressed? How clean is the studio? Do the studio's printed materials appear professional? Some differences will be clear right away. Others might take a good deal of sleuthing. Regardless, there will be notable differences.

Do you have what it takes to be professional? Only you will know for sure. Many photographers take beautiful pictures but do a terrible job at marketing, dealing with employees, customers, etc. I truly believe that many studio owners are not making a decent income because they got into this business just to take pictures. They gave no thought to the other elements involved. Remember, just because you love to take photographs does not mean you are cut out to be the owner of a photography studio.

There are others who confuse being busy with being successful: they think that if they are busy, they must be making money.

2. MASTER YOUR PHOTOGRAPHY SKILLS

Mastering your photography skills is something that is going to take at least two years, in my opinion. Basic camera functions can be learned from books and just plain old practice. Posing, lighting, and interacting with the client will take more time to master. In this chapter, I will walk you through the skills needed to create beautiful portraits of your subjects while they are enjoying every minute of the process.

After the marketing and business section of this book, technique is the most important topic. Why is photography less important? Because without good business practices and marketing, there will be no demand for your work.

WHAT MAKES A BEAUTIFUL PORTRAIT?

What makes a beautiful portrait? Ask several photographers and you will probably get several different answers. There have been countless books and other materials produced on this very subject. Unless you want your photographs to look like the ones made at your local department store,

When you fully understand the technical aspects of creating an image, you can focus on the subject and the stylistic concerns of the shot.

there are certain things you will need to do. I am going to show you what I think is important to achieving a professional looking photograph.

Studio Lighting. The first thing you must completely understand is lighting. To create a professional looking photograph you must create depth, form, and shape to the face. In other words, we do not want flat lighting on our subject. In my camera room, I start with an overall fill light. I bounce the light from two flash heads into two large halos to produce a reading of f/5.6. This light produces soft, even illumination on the subject, much like the lighting effect achieved on a cloudy day.

Fill Light. The fill light is the foundation of good lighting, but by itself it is not going to give us the result we want. To create fill, many photographers use a reflector to bounce some of the light output by the main light. This is okay to do, but if you are photographing several sessions a day, it

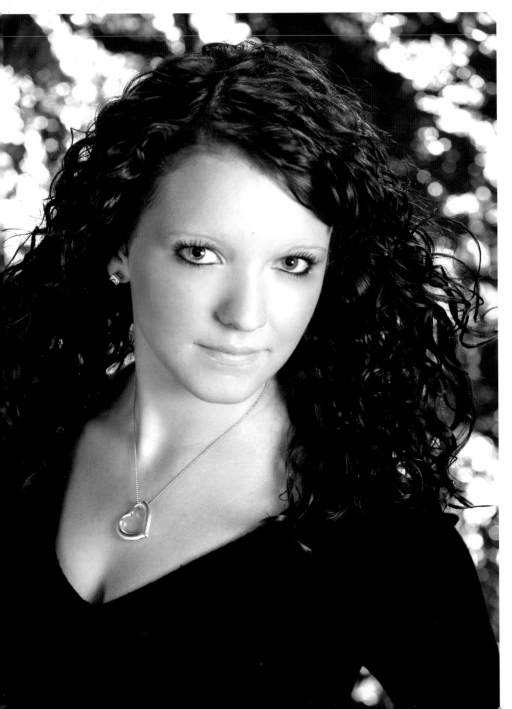

The eyes are the most important part of any portrait. Properly placed catchlights give the eyes life and engage the viewer.

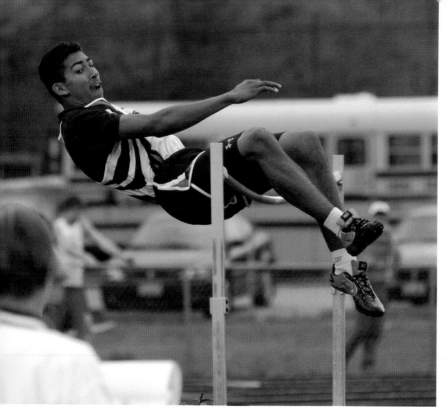

Having a solid skill set will allow you to create masterful images in a variety of situations that less qualified photographers will miss.

will slow you down. If you work with the fill light behind you at all times, you will definitely pick up speed in your sessions.

Main Light. Next, we introduce the main light. This light creates the shadows on the side of the face, which helps to produce the appearance of depth or dimension in the portrait. My preferred main light source is a 16-inch parabolic light positioned to the left or right of the subject's face. I have tried softboxes and umbrellas, but they do not give me the crisp light and snap that I like in my photographs. Another good reason to use a parabolic light is that very few photographers use them, thus giving your photographs a different look. Softboxes are easier to use and much more forgiving if not placed properly. A parabolic light must be in the correct position or something isn't going to look right. I don't want my pictures looking like my competition's shots. By properly placing the parabolic light on the subject you will be well on your way to creating a beautiful portrait.

Your number one goal in placing the main is to achieve catchlights in the eyes. This is more important than any lighting pattern on the face.

Proper lighting ratios are also very important. I like about a 3:1 ratio on the face. This is achieved by having your main light set at about f/8 to f/8.5. Where to direct the light onto the subject will depend on the facial structure, teeth, eyes, hair, and other factors.

Hair Lights. Hair lights and background lights are also important tools. The color and length of the subject's hair will determine how much light

is needed and where the light source should be positioned. In general, lighter-colored, shorter hair will require less light than longer, darker hair. If your subject has short hair, you will only need to add enough light on the hair to keep it from blending into the background. Be careful not to have any of the light spill onto the subject's ear or nose. Setting your hair light about a stop or two less than the main light and positioning it approximately 12 inches from the subject's head is a good place to start. Using a hair light with louvers on both sides will be a big help in controlling the light.

When you are photographing long-haired subjects, you'll need to add more light. Positioning the light higher will give you broader coverage. I sometimes use two lights when photographing females with long, dark hair. The overhead light is used to illuminate the top of the hair, while a second hair light, placed to the side, will illuminate the length of the hair. For someone with dark hair, the power level of this second light can be equal to or a step or more higher than the first light, depending on the desired effect.

Background Light. A properly placed background light will cast a nice glow behind your subject. The amount of power needed from the light and its ideal placement will depend on several factors—the color of background, the length and color of the subject's hair, and whether you are

Whether bold or subtle, the role of a background light is the same: to separate the tones of the subject's hair and clothing from the background, contributing to the sense of depth the overall lighting setup creates in the image.

Because all of your subjects have different features, it is impossible to suggest certain light settings or placements that will work every time. What you need to do is master the lights in your camera room and be familiar with the output and direction of them. Be sure that you select flash units that have accurate modeling lights so that you know exactly where the flash will go when you fire the camera.

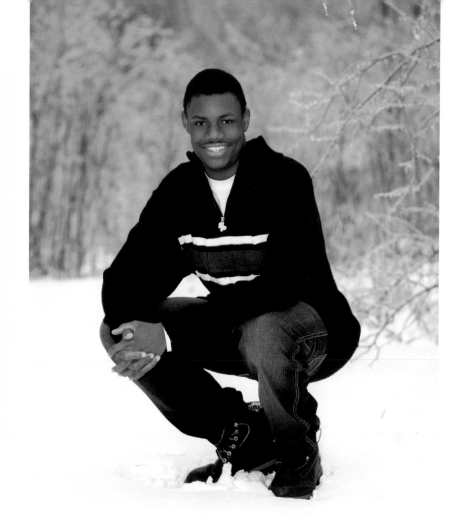

This subject's outfit and the background were perfectly paired, resulting in a cohesive outdoor portrait.

using a gel to add color in the subject's hair. The glow from the light can help tonally separate your subject from the background when he or she is wearing clothes similar in tone to the background or when the hair color is tonally similar to the background.

I've seen studio photographers work without hair lights and background lights. Please remember if your photographs are going to look like the department store pictures, the client has no reason to pay you more money for your work.

Outdoor Lighting. Outdoor lighting should be easier to master than indoor lighting, which sometimes requires six to eight strobes placed just right for each picture. The key element to outdoor light is "seeing" the light. A good outdoor portrait will have shape and form to the face, just like a photograph taken indoors.

The best lighting tools for outdoor portraiture are a reflector and a gobo. (If you place your subject in the correct position in relation to the

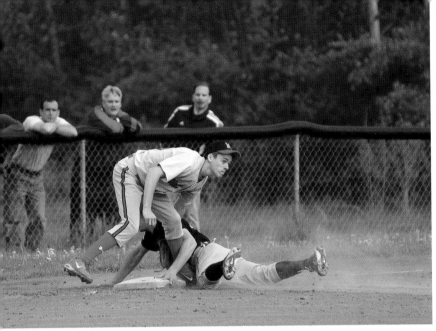
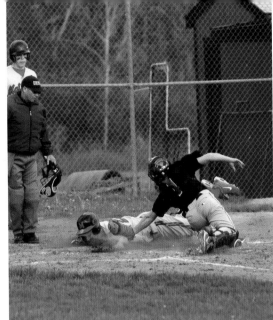

direction of the light, you won't even need a gobo.) Many times I use natural gobos such as a fence or trees to block light and create the desired effect. Flash can be used outdoors, but I try to avoid it because of the flat lighting effect it creates. One of the biggest lighting mistakes I see over and over again is dark eye sockets. This is the result of no light being placed into the eyes—either with flash or, better yet, a properly placed reflector panel. You don't want your outdoor subjects to look like raccoons with dark shadows around their eyes. Lighting is a skill that takes both time and practice to master.

Posing. Posing, like lighting, is something that takes much practice. One of the main elements to good posing is making your subject look natural and relaxed. Try to make the subject appear as if they didn't know you were going to take their picture. One of the best things to do to improve your posing is study the photographs you have taken. Look at every little detail of the pose.

Head and Shoulders. Many things can be done to help your subject look better in their photographs. Let's start with a basic head-and-shoulders pose.

If there is one flaw that is common to most head-and-shoulders shots, it's that the camera angle is too low. Look in the high school yearbooks from your area and you will probably see many high school seniors looking down at the camera. In my opinion, the lens should be several inches above the subject's nose. This will cause your subject to look up at the lens, creating a very pleasing effect. Their eyes will look more attractive, and the higher camera angle will even help to slightly thin the subject's face. I use a small step stool in my camera room to get to the correct height for my photography.

Learning to anticipate the "critical moment"—the peak of action in a photograph—will help you clinch the sale when it comes to photographing sports.

EQUIPMENT

To achieve professional results, you need to have professional equipment. I use Photogenic Studio Master II lights and Photogenic power lights for background effects. Be sure that each of your lights has its own power pack. You want to be able to adjust each of your lights without affecting the power on another light. Just like a master carpenter, you must have all of the right tools and know how to use them to create beautiful work.

Always have your subject at an angle to the camera for a head-and-shoulders pose. If the subject is sitting on the posing stool with his body turned toward the right, then his head should be turned back toward the lens. By turning the head and shoulders in different directions, a more dynamic image is produced.

Another reason why you should strive to differ the head and shoulder angles in relation to the camera is that photographing someone straight-on to the camera for a head-and-shoulders pose will make them look broader. If you want to see what someone looks like in a straight-on pose, look at your driver's license. That pretty much says it all. If your subject is very small—let's say a high-school senior girl who weighs about 95 pounds—you might get away with photographing her straight-on to the camera. For everyone else, posing at a slight angle to the camera is best. The bigger the person, the more you should turn them away from the camera.

Three-Quarter-Length Poses. These poses are done with the subject standing and are cropped approximately at the knee. Again, you want the subject positioned at an angle to the camera. Placement of the hands is important in this type of pose. Having the clients' thumbs anchored in pants pockets, on their hips, or on a prop works well. Be sure not to crop hands or arms out of the image. I would not recommend a three-quarter-length pose for anyone who is overweight. Remember, your clients want to look their best, so choose poses that flatter them.

Full-Length Poses. The rules that apply to three-quarter poses also apply to full-length shots. If a high school senior brings in a lot of props for band, sports, dance, etc., then a full-length pose works well. Note, however, that full-length poses make the subject's head appear small, particularly in wallet-size photographs.

Photographing someone straight-on to the camera for a head-and-shoulders pose will make them look broader.

Full-length poses offer a reduced view of the face—especially in smaller print sizes.

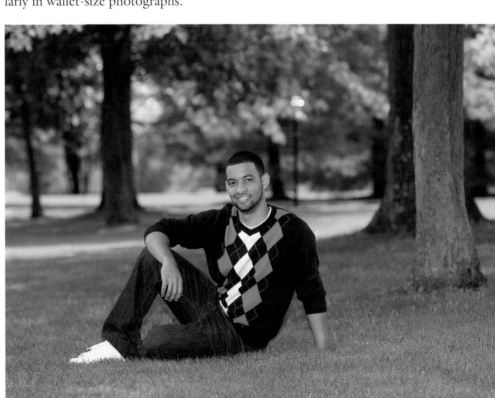

Overweight Subjects. People who are overweight need a lot of help when being posed. Most anyone can pose a thin, beautiful model, but posing someone who is overweight is much more challenging. I remember years ago, an instructor at a seminar I was attending taught me what he called the "H and H" method for posing an overweight subject. H and H stands for hunt for something to hide behind. In other words, have your subject peeking around a panel, tree, or anything that can help hide their weight. Keep your camera angles high as well. Never photograph someone who is overweight sitting in a chair. I'm truly amazed sometimes at the photography I see done by "professionals." Nothing has been done to enhance the appearance of the person sitting in front of the camera. In fact, many times they have made it worse! With a lot of practice and time you can master the art of posing just about anyone. Study your photographs in great detail and compare them to those created by people who consistently make outstanding images.

LENS SELECTION

Working with the correct lens is a very important element to beautiful portraiture. When photographing people, always use the longest lens possible. A long lens will flatter your subject's facial features and distort the background, making your subject stand out in the photograph. Your outdoor pictures in particular will look better when the background is muted and out of focus because a long lens and a large aperture were used. Keep

Extreme wide-angle lenses, including fisheyes, can be used for special effect.

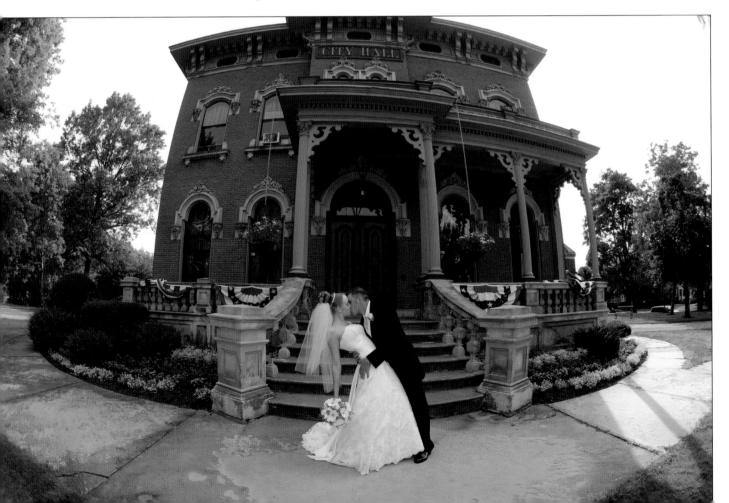

LEFT—A greater depth of field results in more background sharpness. Here, it helps to set the scene for the action. **RIGHT**—A narrower depth of field helps your subject pop out from the soft background.

in mind that a shallow depth of field will enhance your photograph's background, but your depth of field will be very limited, therefore making focus critical. Sometimes it is fun with high school seniors to break the rules and use a short lens to distort a basketball, football, band instrument, etc., by having them hold it out in front of them. You can create some pretty cool effects using this method. Using a fish-eye lens can allow you to create unique images at weddings. It's a good idea to chose a lens that the average consumer is not going to have at a wedding. Your photographs should look different from the ones that Uncle Harry is snapping at a wedding reception.

PRACTICE, PRACTICE, AND MORE PRACTICE

How do you get to Carnegie Hall? Practice, man, practice! I'm sure most of us have heard that joke. How did I learn how to take beautiful portraits? You guessed it: practice, practice, and more practice. Unless you are truly gifted in posing and lighting, there is just no way around it. I think playing the piano is a good analogy. You can learn all of the notes fairly quickly, but being able to play beautifully will take considerably more time. Photography is the same way; the more you do it, the better you will become.

Learn good posing and lighting from successful photographers in the business and practice what you see in their photographs. Study work from

photographers who are where you want to be. I have been taking pictures professionally for over twenty-five years and I still study every photograph I take to evaluate the lighting and posing. Being good at posing and lighting is a journey, not a destination.

VIDEOS, BOOKS, MAGAZINES, and SEMINARS

Much of what I have learned over the past twenty five-years has been through videos, DVDs, books, magazines, and seminars. I learn best by simply doing. As I mentioned earlier, I have always studied my photographs for all the details that make a photograph look great. Amherst Media, the publisher of this book, has over the years published many fine books on all sorts of photography (to view their complete catalog, go to www.amherstmedia.com). Attending seminars is a great way to learn and network with others. I highly recommend joining state and national photography organizations. You can't live long enough to learn all of the marketing, business, and photography skills you need by yourself.

You can't live long enough to learn all of the marketing, business, and photography skills by yourself.

FIND A MENTOR

Finding a mentor is a critical step in learning your new occupation. My daughter is an eighth-grade English teacher. In addition to all of her classroom work, she spent several semesters being mentored in the classroom with different teachers and school systems. This was part of the curriculum to be a teacher. Just about every profession I can think of requires some kind of mentoring experience. Find someone who is operating a successful studio and offer to work for free just so you can learn. You are going to want to find someone who has excellent business skills. Remember that capturing wonderful photographs without superior business and marketing skills is a recipe for failure.

BE HONEST WITH YOURSELF

The photography business is quite different than many other businesses. You are not just buying something wholesale then selling it retail, you're creating the product, then marketing and selling it. Before diving into the business head first, ask yourself whether you have what it takes to make it in this industry. Do you have support from your family? Do you have the drive, compassion, and desire to take all of the lumps and bumps you're likely to face? Have you been successful at other things in your life? Do you have the right personality for this very people-orientated business? Are you willing to take risks? Be honest with yourself and come up with a solid plan for making the most of your business.

3. PSYCHOLOGY OF A PHOTOGRAPHY SESSION

CREATE A GENUINE INTEREST

Creating a genuine interest in your client when they come in for a photography session can pay big dividends when it comes time for them to place their order.

At our studio, we try to pamper the client as soon as he or she pulls into the parking area. If it is raining when the client arrives, someone will greet them outside with a large umbrella and escort them to the door. We also help them carry any items they may have brought for their session.

As the client approaches the door to the studio, the first thing she notices is her name on a marquee sign near the entrance welcoming her to our studio. The door to the studio is beautiful; it has a very rich look and feel to it. I have visited studios with dirty, squeaky, front doors covered with photography association stickers from years past. I've been at some studios where you have to jiggle the doorknob just right to get into the place!

LEFT—Learning about your subject's interests will allow you to interact with him or her more naturally, and this will help you produce images that have meaning to the client. This, in turn, will help you to increase your sales. **RIGHT**—A great expression is key to creating salable images. This image shows a white birch that has served as a framing element for many senior portraits. The trunk focuses the viewer's gaze on the subject's smiling face.

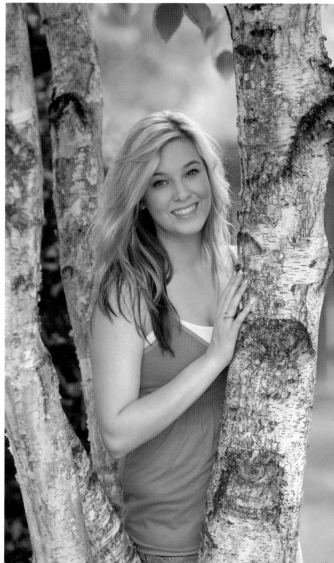

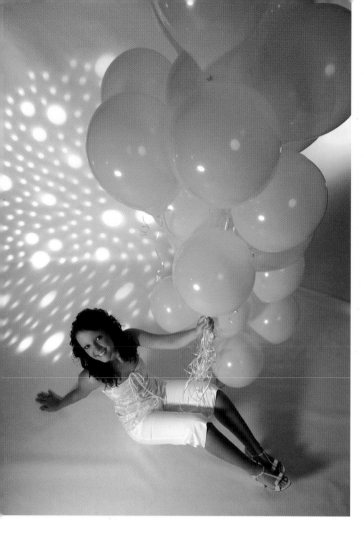

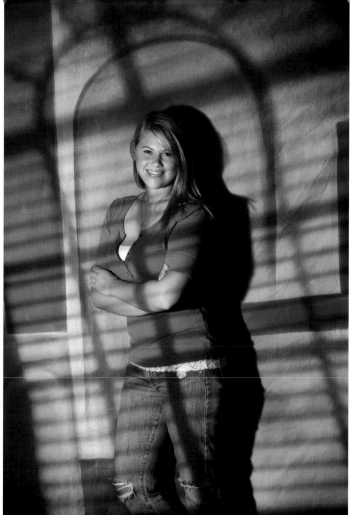

Once the client has entered the studio, we guide her to the dressing room. On the dressing room door, there is a small framed sign with a mini spotlight shining on it that says "This dressing room reserved for [client's name]." Once again, we are creating excitement even before the session begins. Inside the dressing room there are two mirrors mounted on the walls, a full-length mirror on the door, a bench built into one of the corners, clothing hooks, a clock mounted on the wall, and an electrical outlet for a curling iron, hot rollers, etc.

Once the client has everything situated in the dressing room, I review the clothing and props that they have brought in and ask if there is a certain pose, prop etc., that they would like. Some clients request a certain pose or prop but most leave it all up to me.

Once we have the clothing changes in place, we start the session. I always shoot with the room lights low so that I can see the lighting effect that the modeling lights are creating on the subject. This also creates very nice mood lighting and makes the client feel special.

From the moment the client sits on the posing stool I explain what I am doing and why I am doing it. It is important for the subject to know

Left—A high camera angle helped to create this dramatic image. A projection box was used to create the white dots in the background. **Right**—Creating a relaxing mood at your studio will help your subjects be more relaxed in front of the camera.

exactly when you are going to take the photograph. Nothing can be worse than sitting on the posing stool with no idea what the photographer is doing or when the camera is going to fire.

LISTEN AND ASK QUESTIONS

Constant conversation with your client is essential for good expressions, so find out what interests your client and ask engaging questions. Establishing a bond with your subject will increase the subject's comfort level, and their relaxed demeanor will result in better, more genuine poses and expressions in the final prints.

I find it easy to communicate with my clients, especially the high school seniors. Seniors are very savvy. They can tell in a heartbeat if you are not trying to form a genuine bond with them.

Remember that if the client leaves the session liking you, there's a pretty good chance that they will like the pictures you took of them and will be more likely to show their appreciation in the sales room.

PERSONALITY IS EVERYTHING

It's difficult to teach you personality from a book. The hard facts are that people who have a wonderful personality are probably going to succeed at about anything. Before I got into photography, I was very fortunate in my career at General Motors to be around some extremely talented managers. With very few exceptions the people who rose to the top were not only exceptionally bright but had a great personality. They just had the knack for getting people to do their jobs—and enjoy them as well. What does this have to do with photography? Plenty! A photographer with great people skills has a much better chance to succeed. Not only will his clients be happy, but he will have employees who enjoy working for him. What a combination for success!

CREATE A RELAXING ATMOSPHERE

Much of the overall atmosphere of your studio is created by you and your staff. As the studio owner, your outlook will impact your employees. If you are a warm, fuzzy, easygoing person, your staff will be pleasant too. If you are uptight and unpleasant, you'll find that your employees will feel the same way.

When your client enters your studio it must be clean and well lit, and it should even smell good. We have a liquid fragrance we put in a heat ring on one of our lamps that emits a pleasant scent that you notice as soon as you walk into the lobby.

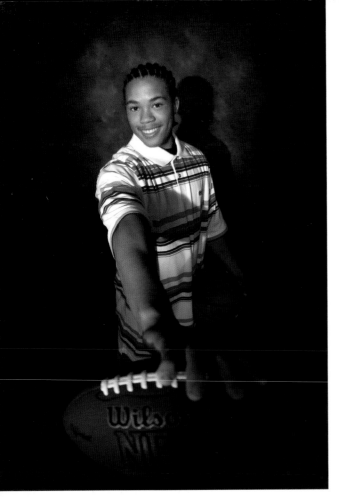

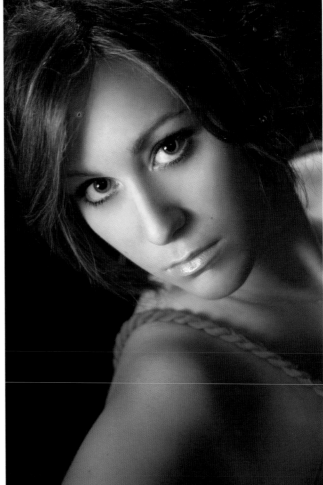

Be sure to have comfortable chairs for your customers to sit in when they are placing their orders or waiting to be photographed. (Hopefully nobody is waiting more than a few minutes.) We have cushioned arm chairs around a large table for our clients to view and place their orders. When clients come into your studio to place their order, you want them to be as comfortable as possible. I remember once going into a studio and seeing a counter where the customers stood the whole time placing their photography order. Talk about how not to do something! Your furniture does not have to be expensive, but at least be sure that it's comfortable.

Visit other facilities and take note of the layout, furniture, and the general cleanliness. You will be surprised at what you notice when you're really looking.

LEFT—A fish-eye lens was used to create the distortion in this unique sports shot. **RIGHT**—Here, the 3:1 lighting ratio on the face, beautiful hair lighting, and a dark background added up to an outstanding photo.

4. BUSINESS STRATEGIES

*I*n my opinion, business management is the most important topic covered in this book. Unfortunately, many of you will breeze past this section and study posing, lighting, and the camera section of this text! Those who do will be doing themselves a disservice.

Most of you got into photography because you like to take beautiful pictures, not because you want to run a business. If you want to make a decent living, however, it is imperative that you have basic skills in marketing and pricing.

Running a photography business is very different from many other businesses because, as an artist, you are both a manufacturer and a retailer. Let me explain.

When you walk through a mall, you see all types of stores selling just about anything. The shop owners buy their goods at wholesale and sell them at a mark-up (retail prices). To determine the retail price, they must calculate overhead, employees' pay, insurance, rent, and anything else a studio owner needs to run their business. All of these costs must fully be recovered before they begin to make a profit!

Running a photography business is very different from many other businesses because, as a studio owner, you are both a manufacturer and a retailer.

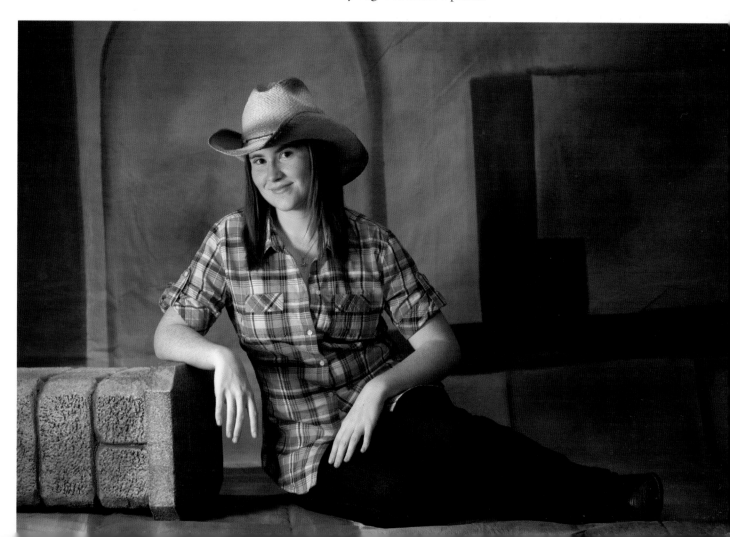

To make a profit in this business, you must cover all of the costs that shop owners typically face, but you must also charge for your time and talent in creating your merchandise. You must also figure in compensation for the purchase of the tools you need to create your work: cameras, lighting equipment, props, film, flash cards, computers, and anything else you require. Don't forget the value of your education: the amount of time and money you have spent learning photography.

PRICING

Given all of these variables, how in the world do you even begin to know what to charge? I'll tell you what most photographers do: they get their hands on a competitor's price list and simply charge a little less. Now that's a scientific way to determine what to charge for your goods and services!

Don't forget the value of your education: the amount of time and money you have spent learning photography.

I once asked a photographer who was fairly new in the business how she determined her prices, and she said, "Oh, I just see what the lab charged me and multiply that number by three!" If the lab charged her $3.00 for an 8x10, she'd simply charge the client $9.00 for the picture. The only cost she was figuring into her calculation was the lab bill! What about all of the other costs that went into producing that one 8x10?

Achieving a reasonable profit margin is not an easy task, but there are some basic things that must be considered to ensure profitability.

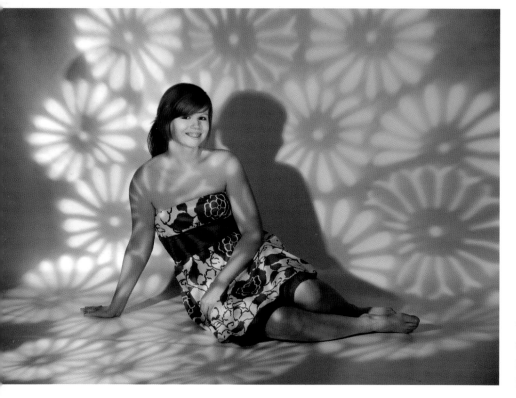

Your pricing must factor in all of the things that go into making your images—things like the cameras, lenses, backgrounds, props, and more.

Not all of your expenses show up in the frame—don't forget to consider costs like your education, the water bill, insurance, and more.

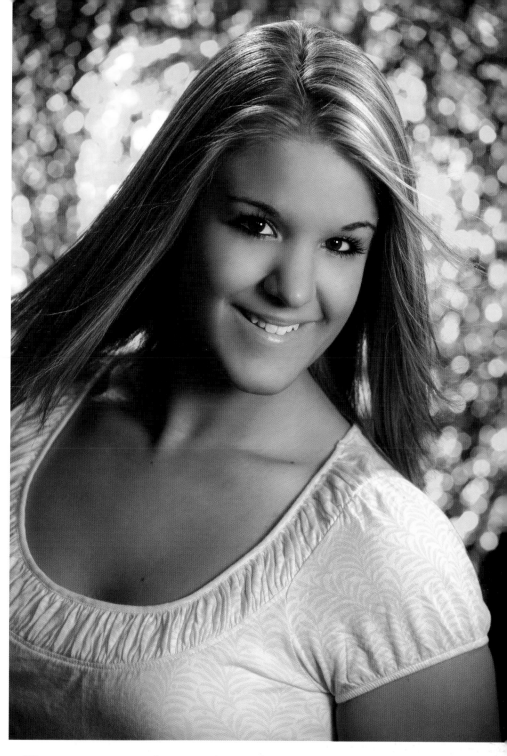

There are two types of expenses in your business: fixed and variable. Fixed expenses are the same every month regardless of your volume. Costs such as rent, insurance, basic phone service, and electricity are examples of fixed costs. Variable costs are associated with the amount of business you are actually doing. Things such as lab bills, wear and tear on equipment, number of employees needed, frames, and photo mounts are examples of variable cost expenses.

Offering several different products in your studio is a good idea, but not every product will provide the same level of profitability. For example, if you photograph a one-hundred-member little league team and average $25.00 per player, your gross is about $2500. From this, you must subtract all of your costs to deliver the final product. The lab bill will be $500 to $700, the photo mounts will be about $100, your labor costs to assemble the job will be approximately $100, and don't forget some leagues want a kickback (let's assume $250). As you can see from this example, you have reduced your gross of $2500 to perhaps $1350. Also, a portion of the "profits" from this job will go toward the cost of phones, rent, utilities, insurances, and your salary. Compare this baseball job to photographing four high-school senior sessions in your studio. If you average $625 per senior, you will have grossed about the same amount of money but have a much smaller lab bill, no kickbacks, and only a fraction of the cost for photo mounts. Your fixed costs—rent, utilities, insurances etc.—all remain the same for the job, but your variable costs will be much lower. Your lab bill for four seniors, including the proofing and processing of the final product, will be much lower than the baseball job. Here's a breakdown of each job.

A portion of the "profits" from this job will go toward the cost of phones, rent, utilities, insurances, and your salary.

VARIABLE COSTS TO PHOTOGRAPH ONE-HUNDRED LITTLE LEAGUE PLAYERS

1. No film or processing cost

2. Lab bill to print packages—$700

3. Photo mounts—$100

4. Kickback to league—$250

5. Labor to assemble packets—$100

Total: $1350

Note that almost half of the profit (48 percent) is gone before any of your fixed costs are factored in.

VARIABLE COSTS TO PHOTOGRAPH FOUR HIGH-SCHOOL SENIORS:

1. No film or processing costs

2. Lab bill for four seniors—$400

3. Photo mounts for four senior packages—$40

4. Labor to assemble packages—$30

5. No kickback to seniors

Total: $470

Only about 19 percent, compared to 48 percent for the baseball job, is needed to produce the final product for four seniors. Remember, the fixed costs of your operation must be added into the above totals to get a more accurate figure of your total cost of producing the final product.

As you can see from the examples on page 32, different product lines will produce different levels of profitability. You may find that there are some types of photography that simply are not worth offering. For the most part, the work done in your studio should focus on your most profitable products. The exception is with jobs like school dances, which aren't nearly as profitable per client but can be worthwhile based on the sheer volume of the work. The prices you are charging, your volume, and your fixed costs will have an impact on the percentages you are keeping from your gross sales. Getting caught with high overhead and excessive labor costs will quickly lead to trouble. Keep your eyes on your costs at all times.

So, given all we have just discussed, just what percentage of your gross should you be keeping? In my opinion, it should be in the 30 to 40 percent range. Anything over 40 percent means you have your operational costs well under control and are charging the prices you should. If you are keeping less than 30 percent of your gross, you have a profit leak somewhere—maybe prices are not where they should be, your overhead is too high, you have too many employees, or there's just not enough business.

If a lack of business is the issue, think long and hard before being tempted to lower your prices—this is a dangerous road to go down to acquire clients. If not enough clients are calling for appointments, there

The amount of overhead involved can vary dramatically based on the type of job in question.

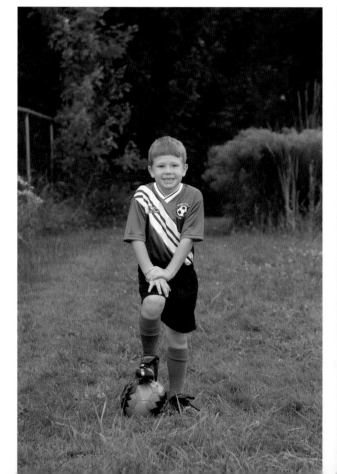

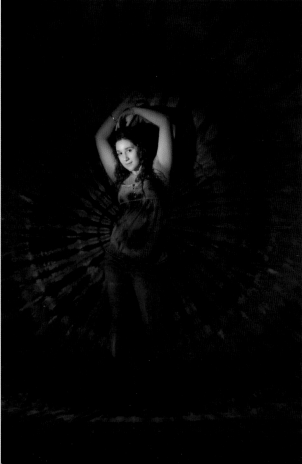

is generally another problem that you need to investigate. Are you offering high-quality portraiture, or do your pictures look like something your clients can get at a department store? Have you spent at least 10 percent of your yearly gross on high-quality mailings and other forms of advertising? This is not easy stuff! Just remember one thing: if you charge big bucks for your photography, you must have a studio that seems worthy of this price.

SURROUND YOURSELF WITH GREAT HELP

Employees. Anyone who runs a successful company will tell you the main reason for their success is the people they have working for them. Dedicated employees paired with good leadership is a winning combination for a great organization. The smaller the company, the more important this is. If you have a staff of just three people and one of them is not pulling their weight, you are running only at two-thirds your potential efficiency!

Finding an excellent employee can be difficult at best. I'm not a big fan of running an ad in the newspaper to find someone. In my opinion, the best route to finding good employees is via former clients. We have had a fairly good success rate hiring a client whom we thought would work well in our studio. You may also consider hiring someone part time and offering them a full-time position if they work out well. Many large corporations today hire a person as a contract employee and later hire them full time if they fit in well. Hiring a family member or a friend usually does not work out in the long term. I'm sure there are exceptions, but most of the time it simply causes problems.

When you find someone who is really performing, pay them well. Good employees are hard to find—particularly in the photography business. In a

If you have a staff of just three people and one of them is not pulling their weight, you are running only at two-thirds your potential efficiency!

Surrounding yourself with a great staff will make your job easier and more efficient—in the camera room and beyond.

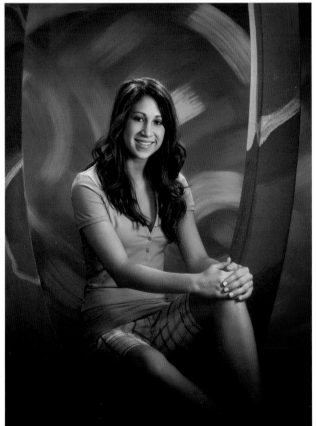

Adding to your staff—on a full-time, part-time, or even temporary basis—can allow you to offer services that may not be in among your own skills.

There are many issues to consider when deciding who is going to be printing all of your work.

small studio operation, an employee needs to be excellent on the telephone, a good salesperson, and well organized. In addition, he or she should have some computer skills, a professional appearance, be pleasant all the time, and, of course, have superb people skills. If you can find someone who can do all this, you have real winner!

Photo Finishing. In addition to having a great employee or employees to help run your operation, you also need some great suppliers.

Your biggest supplier, of course, will be your photo finisher. Choosing a good lab is not easy. There are many issues to consider when deciding who is going to be printing all of your work. Some things to consider are quality, delivery times, prices, and customer service.

Try to find a lab that is well suited to your type of photography. We do so many types of photography, so we need a lab that can print dances, sports jobs, high school seniors, and wedding photography. Some studios send different types of jobs to different labs. Personally, I find it much easier to send all of our work to one lab. You may spend a little more, but I find it less aggravating to deal with one lab rather than two or three.

When you find a good lab, stick with it. We have been in business over twenty-five years and have used only two labs. Our first lab serviced us for over fifteen years. The reason we switched was quite simple: when our previous lab started to grow and add to its facilities and employee roster, the quality of the work began to suffer. It was doing a poor job of managing its growth. A good lab is like a good marriage: you both must have the same goals and standards.

Currently, our lab is Elyria Color Service located in Elyria, Ohio. It is a small lab compared to some others, but its service and quality is simply outstanding! The single best word to describe them would be "consistent." Job after job, print after print, the photographs are all beautifully

ABOVE AND FACING PAGE—Because of studio offers a variety of services, we need a lab that can print everything from senior portraits, to team photography, to wedding images.

printed. It is probably a little higher priced than some of the "mega" labs, but the quality is well worth the cost.

That raises an important issue: pricing. While it might be tempting to hunt for a bargain, choosing a lab on price alone would be like a bride only considering pricing when choosing a wedding photographer—and we all know that's not a good idea! Find a lab that truly has your success in mind. Work with your lab all the time to make the relationship better. You both will profit as you work together.

In summary, find a lab that is an extension of your goals and quality standards. Be honest with them at all times, and if they are giving you great service and prints, be sure to always pay your lab bill on time.

Other Suppliers. Other suppliers will provide your frames and photo mounts, wedding albums, etc. Again, I find it much easier to deal with one supplier for most of our after-photography needs. Albums, Inc., in Strongsville, Ohio, is our major supplier. I feel their service cannot be beat. We have been assigned a customer representative at Albums, Inc., so we deal with the same person every time we call. This makes things go so much more smoothly at the studio. Again, it all boils down to customer service and quality products.

Work with your lab all the time to make the relationship better. You both will profit as you work together.

RUN THE BUSINESS, DON'T LET IT RUN YOU

Many photographers I know—not all, but most of them—try to do most of the work in the studio themselves. They believe that doing so saves them money. Truth be told, when you factor in the number of hours some of these folks work, there are studio owners who are not even making minimum wage. I once heard a speaker at a photography convention say, "Don't spend your time doing $6.00-an-hour work at your studio." He was right; you should spend your time working on your next promotional piece or making long-range marketing plans, not packaging a small job that you could be paying an employee to handle.

Don't get caught in the trap of long hours and no help. You will just burn yourself out, and your business will be negatively impacted. It is extremely difficult to be creative if you are always under stress.

Operate your studio with normal business hours. We are open Monday through Friday from 10:00AM to 5:30PM. We are closed on Saturdays and Sundays. Although we have elected not to, I would recommend being open one evening a week until 8:00PM, and possibly on Saturdays until 2:00PM. If you want to close on a weekday, close on Friday, not Monday. You will get a lot more calls and business on a Monday than a Friday.

CASH FLOW

Without question, the single biggest reason businesses of any kind fail is a lack of positive cash flow. Without cash, you will not be able to operate your business, period. Cash is the number-one ingredient for the success of your business. Do whatever is necessary to be certain that you will have access to cash whenever you need it.

Keeping regular business hours makes it easier for busy families to access you and your services.

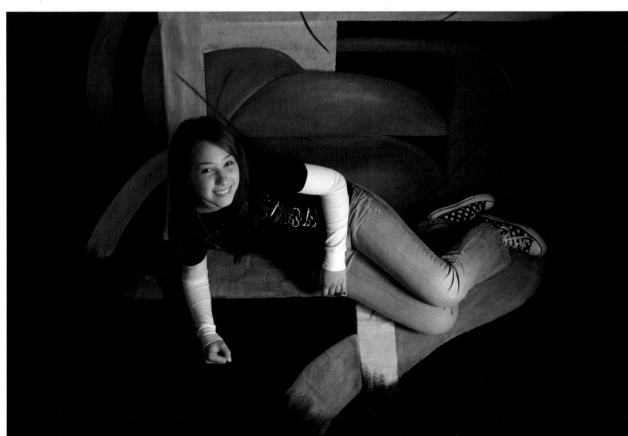

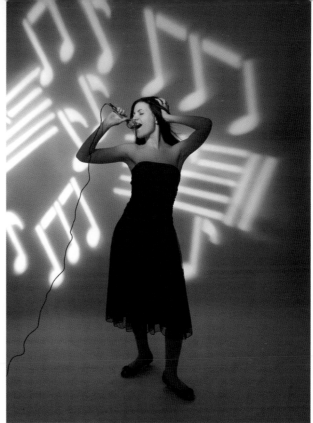

All the creative energy in the world won't lead to success without a solid business and marketing plan.

If you are just starting out in this business, it would be wise to start out small—probably out of your house, photographing weddings, sports jobs, or any type of assignment that does not require a studio. Buy the best equipment you can afford so that, if and when you do move into a storefront, you'll have a lot of the equipment you'll need. Starting small will give you a chance to see if you are capable of properly managing your cash flow. As you progress, you should be accumulating cash for future purchases and the expansion of your business.

If you do not like managing the business side of your studio, find someone who is experienced at small-business startups, and ask for their advice. Remember, without a good, solid business and marketing plan, you're headed for trouble.

KEEP THE OVERHEAD LOW

Bigger is not always better. Several years ago, my wife and I looked at a building that was for sale on a main state route in our community. It had approximately 4500 square feet and was only about twenty years old. The price was right, and the location was great.

After the excitement of occupying a new building passed, though, I started thinking about how much more business we would have to do just to make the same profit we were making in our small, 1000-square-foot studio. To justify this additional space, we would have to hire another

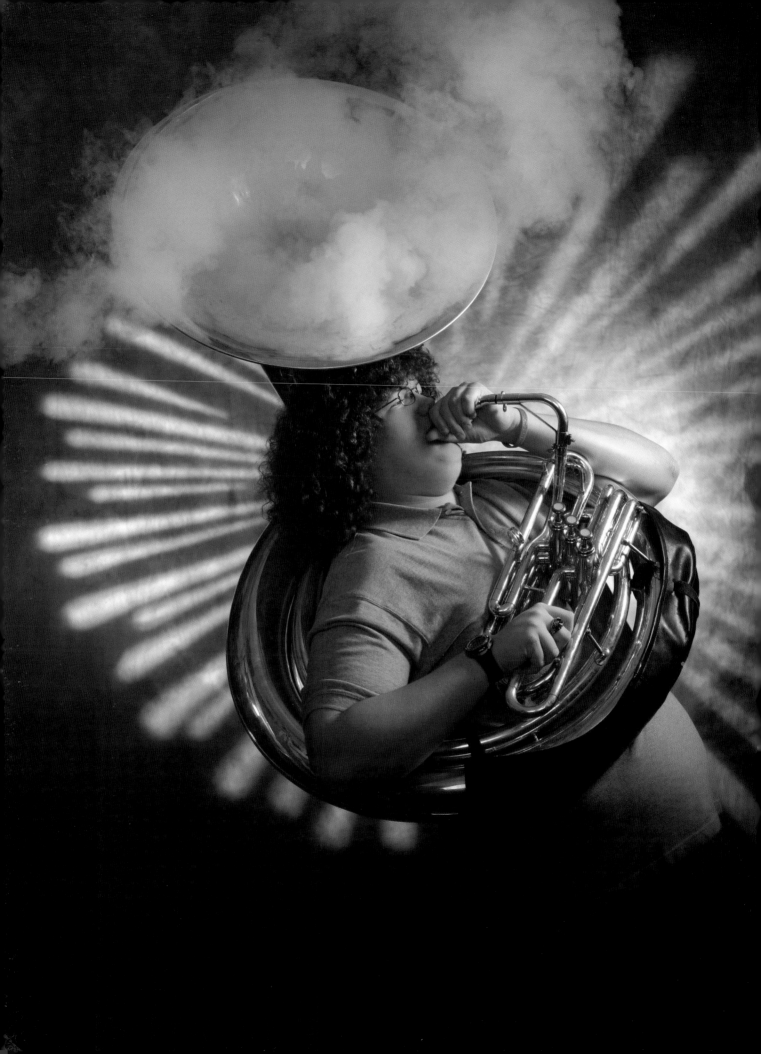

FACING PAGE—Truly customized images—not just cookie-cutter portraits—will make your clients feel special.

photographer, do more volume, and add support staff—just to (perhaps) make a little more income. We could have increased our gross sales by over $100,000 and netted less profit!

How many businesses, of any kind, have we all seen expand too much and too fast, only to be bankrupt in a few years? If you are in the wonderful position of needing more room because your business is growing, control your volume with price. You can make more money and work less. Do not confuse gross income with profit. Keeping 35 percent of $300,000 ($105,000) is certainly better than keeping 20 percent of $500,000 ($100,000). Just think how much more work and help you would need to produce that additional $200,000—all for just a $5000 return! So keep the overhead low. High rent will eat away at your profits. If you can afford it, purchase a building; over time, you will build equity and have a nice nest egg for retirement.

IT'S ALL ABOUT THE SIZZLE

Making your clients feel special is a very important factor in running your photography business. Having lots of sizzle in your operation will set you apart from your competition.

Just what is meant by "sizzle"? In a fine restaurant, a hostess will take you to your table and probably even place the napkin on your lap. When you receive your dinner, it is on fine china with a beautiful presentation—everything is placed just perfectly on the dinner plate. During your meal, your glass will be kept full, and the waiter will ask several times if there is anything further they can do for you. Now, you could have gone to a much less fancy restaurant and gotten a meal for much less money, but you chose a fine dining experience instead. So, why do people frequent restaurants that charge so much more? They want to experience the sizzle!

In the restaurant, the sizzle is the service, the presentation of the food, and the general atmosphere. In your studio, sizzle starts with how the phone is answered and extends to the décor, the cleanliness of the interior and exterior of your studio, and how you dress—simply put, it's the overall impression clients get when they walk into your studio. Without the sizzle, you will never be able to charge higher prices. To be expensive, you must look expensive.

It is all of the details that add up to a first-class operation that will set you apart from everyone else. There must be compelling reasons for the client to choose you over someone else. So, keep your eye on all of the little things, and help your studio rise above the competition.

Without the sizzle, you will never be able to charge higher prices. To be expensive, you must look expensive.

5. THE SALES PRESENTATION

SELLING STARTS IN THE CAMERA ROOM

A good sales presentation has many important elements, none of which are trickery or high pressure. A good sales presentation involves finding out what the client wants and helping them get it. If a client leaves their photo session excited, chances are they will be excited when they come in to view and purchase their portraits.

High School Seniors. During the summer months, we photograph a lot of high school seniors. Most of the time one of the parents, usually the mother, comes with the senior for their session. We always invite the mom into the camera room for her child's session. Over the years, many mothers have told me that other photographers who photographed their elder children didn't allow parents in the camera room. Talk about bad public relations!

In some cases, a mother will choose not to be in camera room during the session, but that is her choice, not ours. Every once in a while I have to put up with a mother who thinks she is a photographer, but I just deal with it rather than chance upsetting my client. If the "photographer mom" wants something I know is not going to work on her child, I do it anyway and then move on to what I know will look correct. She never knows any different.

Allowing the parent into the studio with the senior helps you to build excitement for the sale.

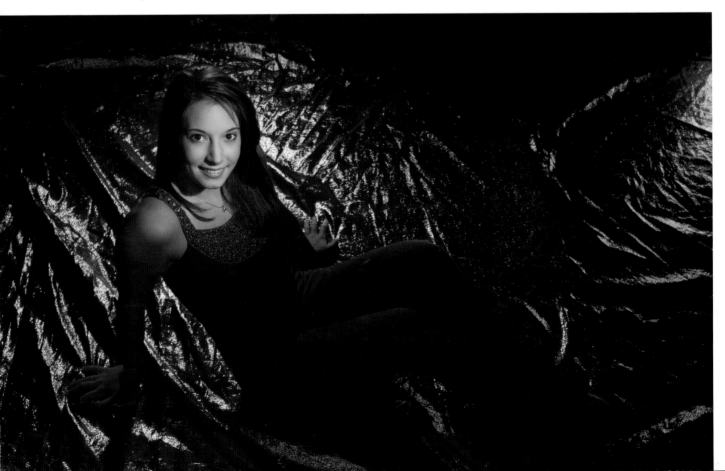

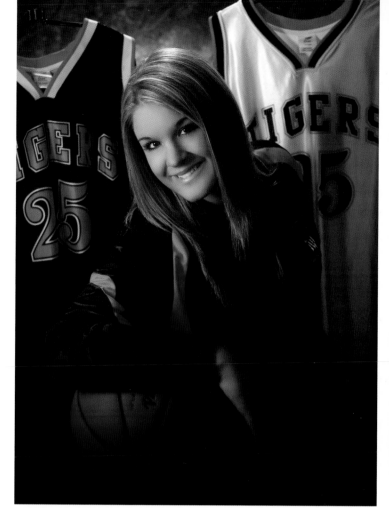

Invite the senior's mom to look through the viewfinder—it's a great chance to start the conversation about what size wall print she might want to order.

When both the student and the parent are in the camera room, you can work to build excitement about the process. We have a nice large comfortable chair for mom to sit in during the session. Many times she will get out of the chair and get involved in the session. Sometimes I have her look through the viewfinder of the camera to see the photograph. This is a good time to start a conversation concerning what size wall portrait they may want and where in the home they will place it. We are selling the pictures before they have even seen them. If the senior and mother have a great experience during the session, the stage is set for selling when they come in to view the photographs.

Wedding Photography. Getting the couple into the studio a few months before the wedding for pre-wedding portraits will give you and your clients a chance to get used to one another before the big day. When the wedding day finally comes, the clients will understand your shooting style, and they will know how you will communicate with them during the various photo sessions throughout the day. A pre-wedding session gives you an excellent opportunity to talk about their big day, creating excitement about how good they are going to look in their photographs. Many

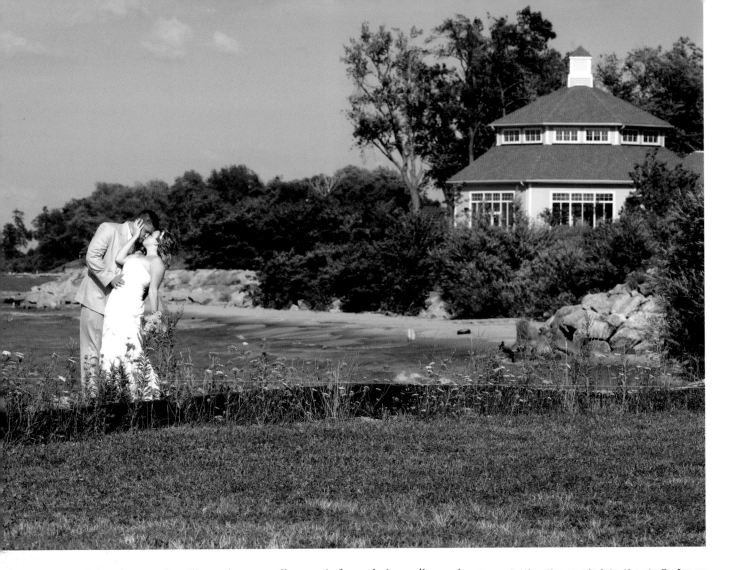

times the couple will purchase a wall portrait from their studio session to display at the wedding reception. This portrait is best displayed at the entrance to the reception. Some studios offer portraits with a large mat that guests can sign their names on, making for a great keepsake for the bride and groom.

Photographing Children. Photographing young children can be a real challenge. You must be very fast and have at least one assistant helping during the session. It is usually best to have the mother bring the child into the studio several days before the session for a clothing consultation; this allows the child to become somewhat familiar with you and the surroundings. This is a perfect time for you to remind mom to think about where in her home she would like to display a wall portrait.

Creating a fun, positive atmosphere in the camera room will be the start of a pleasant buying experience for the client. Be sure that when the client leaves the studio after the session, they have a full understanding of all their options concerning size, finish, frames, etc.

Getting the couple into the studio for an engagement session before their wedding fosters a good working relationship—and sets the stage for better images on the wedding day itself.

SETTING THE MOOD FOR SALES

There are several different ways to present your images to clients. Regardless of the method you choose, setting the right mood for the sales presentation is vital to achieving the maximum result.

Before a client comes in to order, they should have a complete understanding of the price sheet, print finishes, payment options, delivery times, and anything else involved in the ordering process. Once a client has called to book an appointment, we send them a packet of information, including prices and policies. When the client comes in for their session, we go over the price list they received in the mail, show them all of the different print finishes we offer, and explain payment procedures, pricing, packages, delivery schedules, etc. When they come back into the studio a week to ten days later to pick up their proofs, we again go over everything and ask if they have any questions. When they make their appointment to place their order, we again ask if they have any questions about our packages, prices, etc. When the day of the sales presentation arrives, there are no surprises. They have an idea of what they want and how much it is going to cost. This, of course, makes the whole process run much smoother and ensures that it is pleasant for both the studio and the client. Nobody likes surprises when it comes to cost.

When the client comes in to order, be certain to eliminate any prospective distractions. Comfortable chairs, pleasant, soft music, and wall

An effective sales presentation is key to your financial success.

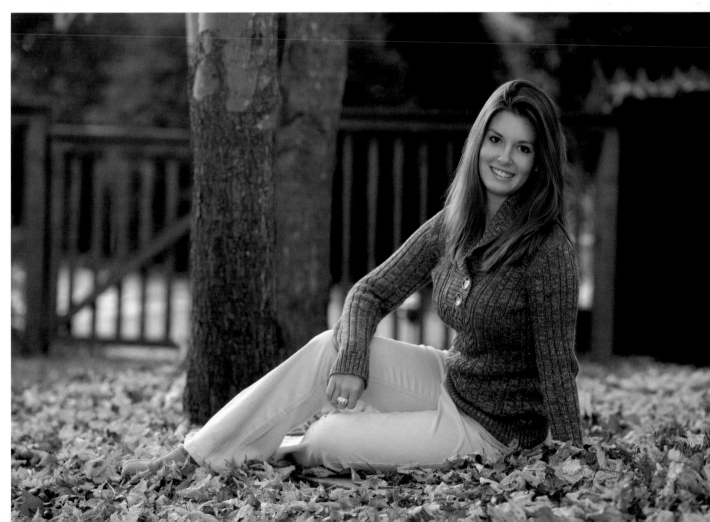

samples of different size prints and finishes will greatly enhance your presentation.

After several months of selling, your salesperson should become an expert. He or she should be able to smoothly answer any questions that arise and close the sale. If after a few months, the salesperson doesn't seem to

Our parents' flyer lets parents know what to expect and what they can do to help ensure great images.

THIS INFORMATION IS FOR YOU, THE PARENT . . .

Your son/daughter has reserved the studio at Williams Photography for the creation of his/her senior portraits. In order that we may provide our best possible service to you, this letter contains information that you, the parent, need to know. As you may know, Williams Photography is not your "run of the mill" portrait studio. If this is to be your first experience, you will probably find our methods are a little different—but the results and our reputation speak for themselves. Please take the time to read this information thoroughly and make sure you and your senior are prepared for the creation process. There are many details in creating great portraits, and Williams Photography will handle most of them. However, you are in control of some of the most basic and critical aspects.

Your investment in Williams Photography portraiture today will be cherished for many, many years. We are always hearing from clients who say their Williams Photography portraits have brought them years of enjoyment—especially once their son or daughter is out on their own. We are sure you will find this to be true, and we ask your full participation and cooperation in making the creation of such an enjoyable heirloom.

Great portraits don't just happen. They are a result of efforts on both sides of the camera. Your studio reservation is a private creation session with our photographer and staff. We will be ready for you. Please be ready for us.

- Please instruct your senior to treat this reservation as they would any important appointment. It's a production in which they are the star. They should be ready and on time. When you reserve the studio at Williams Photography, the studio is yours for that period of time! If for any reason your senior will not be able to keep their appointment, please call the studio. We do offer this word of warning: reservations are in high demand and it's not unusual that rescheduling will not be available for several months.
- We recommend not scheduling other activities on the day of your reservation. Rushing in for a session or "clock watching" while you are in the studio can stress and fatigue you and your senior. Stress and fatigue can be reflected in the finished work–and there's no magic wand that can remove it!
- We have sent a packet of very detailed information directly to your senior. Your portraits will reflect the thought and effort you put into them, so PLEASE READ THAT INFORMATION COMPLETELY. Elements of the portrait that are controlled by you include: sunburn, hair styles, facial hair, nail polish, wardrobe selection, jewelry, make-up, etc.
- One last note. If you wish to "match" a pose or look we have done before, please bring the appropriate items, a copy of the print you wish to match, and let the photographer know your wishes before the creation process begins.

We hope this information is helpful to you. Everyone is very busy these days, and our aim is to give you all the tools necessary to make the process smooth and enjoyable—and the results incredible. The "senior portrait" is the quintessential portrait in American life. It will be enjoyed by generations to come, and we're proud to be the artists you've selected to create your portrait heirloom.

Our flyer called "Express Yourself!" gives advice on selecting props to personalize an image.

EXPRESS YOURSELF!

We encourage you to bring along ideas or items to personalize your session. Here are some ideas to get you thinking:

- Sports uniforms or equipment
- Pets
- Collections
- Hobbies
- Brothers or sisters
- Musical instruments

Bring anything that might help to portray the real you! (*Note:* Some items, such as cars, may require an additional session fee.)

Avoid sunburns . . . We all love the sun, but stay out of it for a few days prior to your session. A little color is attractive, but don't overdo it. We cannot use artwork to change the redness of a sunburn.

Wrinkles show . . . Make sure your clothes are neatly pressed.

We have the miracle of retouching . . . If you wake up in the morning of your session with a brand new blemish, don't worry! We have the ability to restore your complexion in the final photographs. Unfortunately, retouching cannot be done on previews. Retouching is facial only, so your hair and clothing should be exactly as you want them to appear.

Give us a call . . . Feel free to call us as often as you need to. No question is too simple. We want to make your session as memorable as possible and we'll be glad to help in any way we can.

If you wear glasses . . . Glasses cause distortion of your facial features. There also may be glare from photographic lights. Any tint to your glasses will darken under photographic lights. It is therefore vital that you do one of three things. 1) Ask your eye doctor to loan you a pair of frames like your own. Most doctors are happy to help you with this. 2) Remove the lenses here in the studio and replace them after the session. We can help you do this if your glasses have screws that loosen. 3) Try some photographs with and without your glasses.

be performing as you'd like, find a better salesperson. I have talked to many studio owners over the years who have told me that when they had an excellent salesperson, their gross sales increased, even though the photographs were all done by the same photographer. A good salesperson will almost pay for themselves with increased orders.

WHAT DO I WEAR?

For the first outfit, you will want to choose something classic that won't be outdated in just a few years. It is most likely that a portrait made in this outfit will be chosen as a wall portrait for your home. You may consider discussing this with your parents, deciding in which room the portrait will be displayed to help coordinate your outfit with the colors and formality of that room.

We have found that sweaters, suits, and dresses work well. Solid colors or very subtle prints are best, in medium or darker tones. This should be the first outfit you wear.

After the classic portrait, you are ready to get casual. The other outfits in your session should truly represent the person you are. You can actually wear something your friends will recognize you in! This is the time to wear the bold colors or trendy clothing. Below are some points to keep in mind when choosing your clothing:

- **Make sure it fits!** Super-oversized clothes aren't as flattering in photographs. On the other hand, anything too tight may confine you and make you look uncomfortable in the photographs.
- **Color.** Color is one of the most important decisions. Choose clothing colors that are flattering to your skin tone. If you find people compliment you when you wear certain colors, this is a good indication of what looks best on you.
- **Neckline.** The right neckline is also important. If you have a slightly longer neck, you should choose a high neck—like a turtleneck. If you have a shorter neck, choose a V-neck or crew.
- **Shoulder pads.** Tops with large shoulder pads make some people look larger than they are. Make sure you cannot see the shoulder pads through the shirt.
- **Stripes.** If you want to appear in your photos as slim as you are, avoid horizontal stripes.
- **Sleeves.** Sleeveless clothing is not recommended; it makes the arms appear larger than they are. Long-sleeved clothing is the best choice.
- **Sweaters.** Sweaters photograph well all year long. We keep the temperature in the studio comfortable all year, so don't hesitate to choose a sweater just because it is warm outside.
- **Can't decide?** If you can't decide which outfit to wear, feel free to bring along additional choices. We will help you decide which will photograph the best.
- **Dress from head to toe.** Remember to bring everything you will need to complete an outfit. Socks, hose, belts, shoes, and jewelry are some of the most commonly forgotten items.

GETTING READY!

- **Makeup.** If you wear makeup, apply it as you normally would. If you are a diehard natural and do not normally wear any makeup, we suggest a minimum of gloss on the lips and a little mascara. Retouching is provided on your final portraits, but to make your previews look their best, covering any blemishes is recommended.
- **Facial shine.** Bring along some translucent powder to eliminate any shine; we cannot retouch this.
- **Manicure.** Your hands may show in some of your photographs, so make sure your nails are clean and neat.
- **Hair.** Avoid a brand-new hairstyle. Please have your hair ready when you arrive at the studio so only a quick touch-up is required. Hair cannot be retouched, so it is your responsibility to style it exactly as you want it to appear in your finished photographs.
- **Do not hesitate to call the studio if you have any questions!**

GET READY FOR THE GREAT OUTDOORS!

Here are a few tips to make your outdoor portraits fabulous:

- **Do not wear your outdoor outfit first.** We normally photograph you outside last in case it is warm or the wind blows your hair.

- **Number of outfits.** We normally work with one outfit outdoors. However, if you prefer outdoor portraits, we could use two outfits outside.

- **Casual clothing is best.** Casual clothing simply seems more appropriate for outdoor settings. Poses taken down in the grass are often favorites, so make sure you wear something you can get on the ground in.

- **Wear colors you see in nature.** Greens, blues, browns, tans, rose, burgundy, and rich violets are perfect. Avoid black and white!

- **Jeans and sweaters.** Jeans and sweaters are truly ideal. In selecting a sweater, remember the earth tones mentioned above. Also, look for medium to dark tones in solid colors or subtle prints. (We photograph seniors in sweaters all summer long. We work quickly outside, so you won't be in heavy clothing for too long.)

ABOVE AND FACING PAGE—Our senior portrait clients get lots of help when preparing for their sessions.

GIVE YOUR CLIENTS WHAT THEY WANT

I've seen price lists from other studios that I don't understand—and I've been in the business over twenty-five years! When you create your price list for weddings, high school seniors, families, etc., keep it simple. Don't impose a lot of rules and policies that confuse and distract your clients from getting what they want to purchase. They must be comfortable and completely understand what they are getting and paying for. Make it easy for them to get what they want. Having some flexibility built into your prices will give your salesperson some room to move a little on price if necessary. Many times you can move a client up to the next pricing level if they feel they are getting more value for their money. You want all of your clients to leave the studio thinking they got the best-possible product for a fair price.

KNOW WHEN TO CLOSE THE SALE

Once you have presented all of the products the client may be interested in, it is time to close the sale. Closing the sale is a critical component of the sales presentation and positively impacts sales.

Begin to close the sale by reviewing the client's choices, making sure that the order is exactly as the client desires. You may want to say something like, "Okay, Mrs. Smith . . . you want the ultimate senior package for your daughter. That package offers our greatest value." Create excitement and stress the value of their purchase. We usually tell our clients, "The longer you have these portraits, the more valuable they will be to you. You will treasure these photographs forever." You now have helped convince them that their purchase is justified and that they have gotten tremendous value for their money spent.

Next, allow the client to ask any questions. Consider saying, "I think we have covered everything. Do you have any questions?" Once you've gone over any last-minute concerns, continue with, "Your total is $1100. How would you like to take care of the balance? We do accept credit cards."

Finally, thank the client for their business by making a statement like this: "Thank you so much for your business. You can expect to be notified in approximately six weeks that the portraits are ready to be picked up. Thank you again for choosing our studio."

If you stray from the task at hand and do not close the sale, the client may begin to feel uncomfortable and may have second thoughts about what they are buying. With a close, your client has been reassured of the value of their product and is excited about their purchase.

Your bottom line will benefit from clients having all the information they need to prepare for their session, choose their images, and order the products they want.

LIFELINE TO YOUR BUSINESS

The telephone is the single most important piece of equipment in your business! It is the device that all of your business and money flow through. Yet, unfortunately, its importance is lost on many studio owners.

VOICE MAIL

Far too many studios rely on voicemail service to handle most of their calls. We've actually had clients voice their surprise that a person answered the phone when they called our studio. What you are really saying to a client with your answering machine is, "I will talk to you when it is convenient for me, not you." I can't even imagine how much business we have gotten over the years just by answering the telephone.

If you want the best chance of booking their session, clients should be met with a friendly voice—not your voicemail—when they call during normal studio hours.

Here is a little test you can run to find out how good or bad your competitors are at answering their phone. Choose a Tuesday, Wednesday, or Thursday (some studios may be closed on Monday or Friday) during regular business hours and call your competitors listed in the Yellow Pages. I guarantee you that about 70 percent of the time you will get their voicemail. We have done this several times, and every time we come up with the same results.

The client's opinion of your studio begins with their first phone call to you. Establishing your professionalism from the start builds trust for the session itself and enthusiasm for purchasing high-quality products from you.

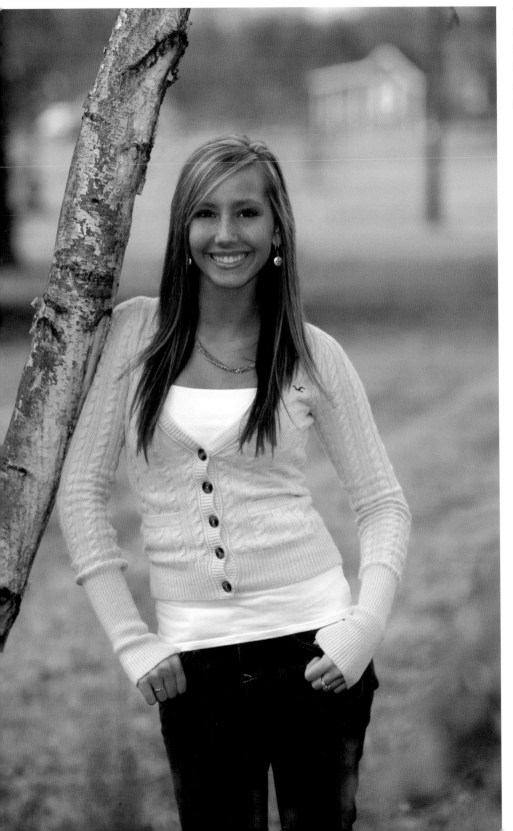

TELEPHONE ETIQUETTE

Answering the telephone correctly will also set you apart from your competition. I'm always amazed at how poorly most business telephones are answered—*when* they are answered. The telephone is the first line of contact many clients have with your business, and having a person who does not come across as professional on the phone will cost you thousands of dollars in lost sales potential.

I occasionally call a business associate who owns another photography studio. Regardless of the time of day I call, his receptionist answers the phone with "Good afternoon." It might be 10:15AM, but at this studio, it is afternoon! I've mentioned this to my friend several times, but nothing has changed. I am sure I am not the only caller who has noticed this.

The telephone is the first line of contact many clients have with your business . . .

Here is some basic telephone etiquette that will help you sound more professional to your clients. Answer the phone by the third ring and say "Thank you for calling [*studio name*] Photography. This is [*your name*] speaking." You have thanked the caller and told them whom they are speaking to. Most of the time the client will call you by name before they address what they are calling about. Speak slowly, clearly, and concisely. There are certain phrases you should never use when speaking to a client:

"We can't do that." What a thing to say to a client! Instead say, "That might be difficult. "Let me see what we can do." If possible, find a solution.

"You'll have to . . ." Never tell a client he or she must do something. The only thing a client has to do in life is die someday. Instead, say, "You'll need to . . .".

"I don't know." Never tell a client "I don't know." Instead, say, "Let me check on it, and I will let you know as soon as possible."

"No." Never start a sentence with the word "no." Try to turn all of your answers into positive responses.

"Hang on a second. I'll be right back." This is the one you hear all the time when you call a business. Instead, try, "Mrs. Smith, may I put you on hold for approximately a minute or two?" Hopefully you have an on-hold message system for your clients to listen to while they wait.

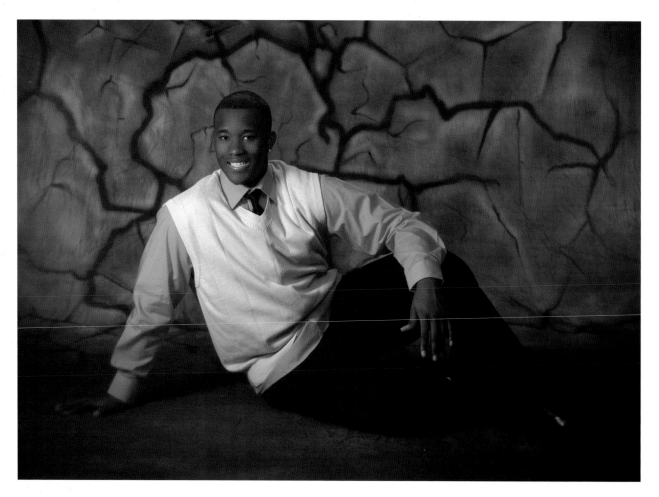

MASTER YOUR PHONE SKILLS

Before assigning anyone to answer your phone, be certain they have been trained or have lots of experience dealing with clients over the phone. Mastering phone skills, like mastering sales skills, takes time and practice. Don't have someone practicing their phone skills on your clients. Be sure they are properly trained first.

HIRE PROFESSIONAL VOICE TALENT

If you want your business to come across as a first-class operation, have a phone system installed. These systems are nothing like the old answering machines. They are all digital and offer great sound quality. They allow you to record messages that will play when your lines are busy or when clients are on hold. This is important, as having dead air on the telephone is a bad idea because the client may believe they have been disconnected.

We have two different messages on our system. The first comes on when both of our phone lines are busy and tells the caller we are currently busy, provides our business hours, and tells them that we will get back

ABOVE AND FACING PAGE—If you want clients to know you are a first-class operation, you need to show them your commitment to quality at every phase of the process.

to them as soon as we can. Since we have two lines plus a fax line, clients seldom get this message during business hours. The second message plays when the caller is on hold.

Consider having a professional voice talent create the messages for your phone system. It's best to hire a female for the job. Women make up the majority of your clients, and, as such, they tend to feel most comfortable speaking to a woman about your services. You won't hear a man's voice if you call Victoria's Secret.

LEFT AND FACING PAGE—Just as your clients care what impression people will get of them from their images, you should care about the impression you are sending every time you pick up the phone.

7. DIVERSIFICATION IS IMPORTANT

My studio isn't located in a large market area. However, there are more than forty photography studios listed in the Yellow Pages of our most recent phone book—and there are many part-timers who do not have ads in the business section of the phone book. With so many photographers competing for new clients, it can be really difficult to make a good profit if you limit yourself to photographing a single client group. At our studio, we photograph high school seniors, high school sports teams, school dances, underclassmen, weddings, family portraits, sports leagues and, occasionally, products.

In this chapter, I will give you all the information you need to be successful in all these types of photography.

HIGH-SCHOOL SENIORS

At least half of our gross sales stem from photographing high-school seniors. As you are probably well aware, there are entire books written about how to photograph and market to high-school seniors. I'll address some of the most essential points here.

Keys to Success. You don't need a studio located on a busy road to be successful with high-school seniors. I know of studios located in highly

At least half of our gross sales stem from photographing high-school seniors.

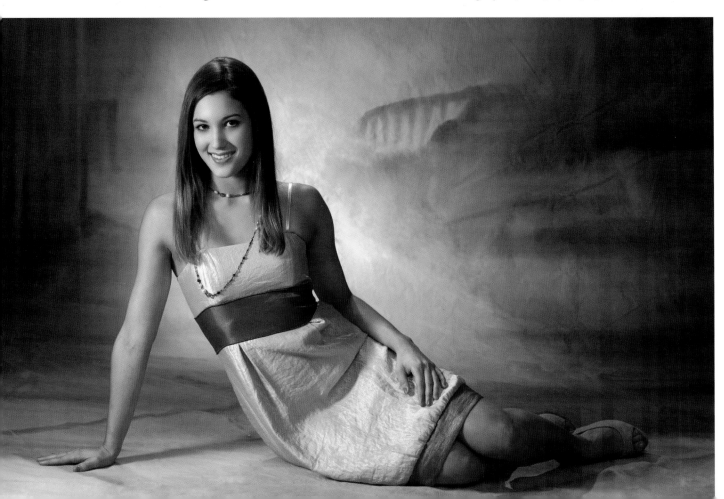

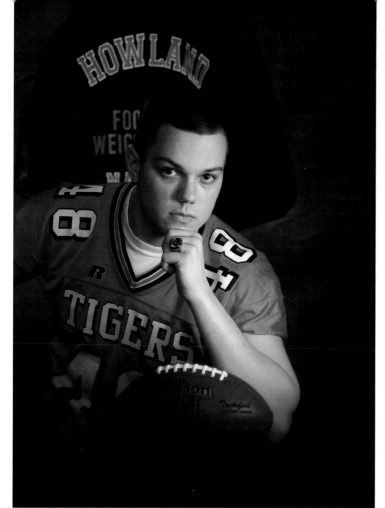

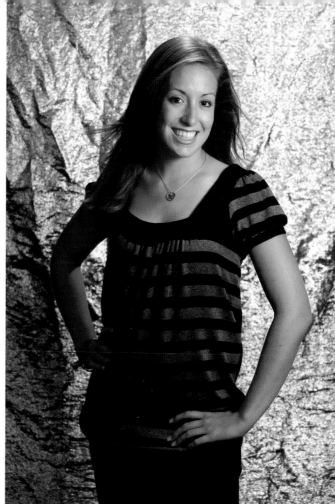

For many studios, direct mail is an effective way to attract senior-portrait clients.

traveled commercial districts surrounded by thousands of high-school seniors that are struggling to draw fifty clients. On the other hand, there are studios that are tucked away in the country that draw hundreds of senior clients each year.

To ensure maximum profitability from this segment of the market, make it a point to attend seminars about photographing seniors. Some of our best approaches have come from tips we've learned while attending such programs. A word of caution: some speakers tend to exaggerate when it comes to numbers, and these little untruths can be hard for beginners to detect. I know of one studio located about fifty miles from ours that claims they are one of the most profitable studios in the country (not the county or state, but the country!).

Though it is hard to say why some studios draw more seniors than others, direct mail seems to work well for many studio owners. Another good way to get their attention is with a mall display that features senior portraits. (We'll take a closer look at marketing in the following chapter.)

The experience that the students have in your studio is probably just as important as the pictures they receive. Word of mouth will make or break

LEFT—We offer three main session types and a selection of add-ons.
ABOVE—Our summer sessions flyer offers seniors big savings.

you with the seniors. Success in this category is, I think, simply a matter of personality. If you are uncomfortable with seniors or find it annoying to talk with them, they will pick up on it. Today's high-school seniors are very mature, and they know what they want. Talk to them as you would to any adult. Find out what their interests are. I'm always amazed at what some of the students are involved in, and I enjoy being in their company.

Session Fees. We offer several session types for seniors—from a basic head-and-shoulders session to an indoor and outdoor session, black & white session, and sessions with cars, friends, sports gear, or just about anything else you can think of. Session fees are certainly not big money makers, but I think you should charge according to your time and the number of proofs or images the client will see.

Booking an appropriate block of time will provide for a good experience for the student and keep you on schedule throughout the day. Some photographers let seniors bring whatever they want with no regard to time and materials. However, to run a smooth operation, you need to know

how much time you will need to spend with each client. Therefore, when the senior or parent calls to book their session, we find out what they want included in their photographs. This will help you determine how many session modules they will need. We have used session modules for many years and find it to be a good way to control session times.

In our studio we offer three main session types or modules and four add-on sessions or modules, as shown on the facing page. Using this system keeps me on schedule and gives the client the ability to book exactly the type of session, or sessions, they want.

Don't get caught in the trap of spending three hours photographing a senior only to have them buy a $200 package. Institute a minimum order if you are spending over two hours on a session, or set the session fees high enough to cover your time.

Several years ago we began to require that all session fees be paid in advance of the client's appointment. The client can either make a credit card payment by phone when the session is booked or submit payment by mail. If they choose to send the payment in the mail, we send out a reminder card stating that the session fee must be paid by a particular date (usually, one week after the session is booked). The card also informs the client that if payment is not received on time, their spot will be lost. We have had

Having clients pay their session fee in advance just about eliminates no-shows.

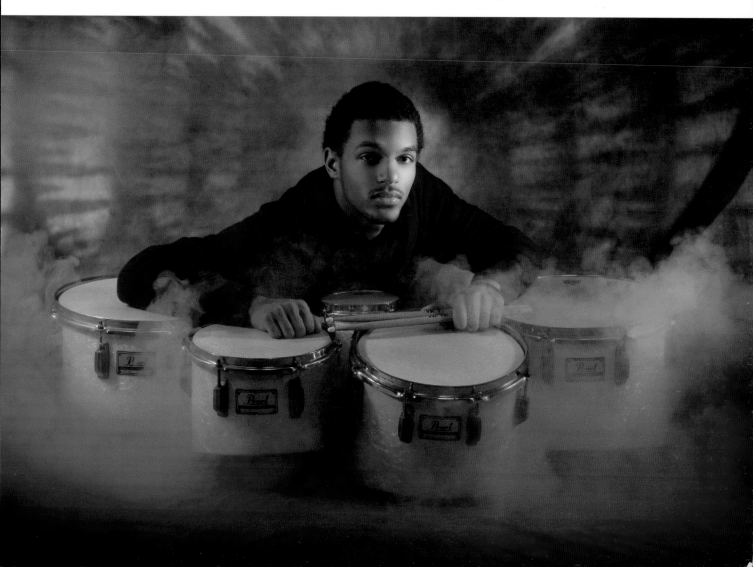

very few complaints about paying in advance—and it just about eliminates no-shows.

The Session. After the senior has booked their appointment and paid their session fee, we send out a packet of information including a letter confirming the date and time of their session, directions to the studio, a price list, and a list of any specials we may be running. We also send out a separate letter to the parents about the photography session their child is going to have. The day before the senior is to come in for his session, we call to remind him of his session date and time and ask him if he has any other questions or concerns.

When the senior arrives at the studio, we have everything ready for him to have a great experience. We have his name on a sign outside the studio and on the dressing room door. He is greeted at the door, and we help bring all of his things in from the car. To most high-school seniors, getting their portraits taken is a really big deal.

Before we start the photo session, one of our salespeople will explain the complete process—to both the parent and the senior. Everything is explained in detail—from how they will see their pictures, the prices, different finishes, and the delivery schedule. The more information you can provide, the fewer problems you will have.

When we start the session, I ask the senior if they have any particular pose or background in mind. Most of the students leave everything up to you, but once in a while you will get a request for something they have

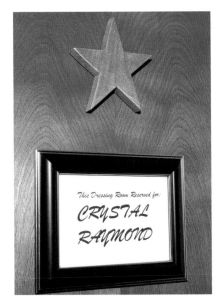

Special touches like these personalized signs will help build excitement and reinforce the idea that the client has made a wise decision in choosing your studio.

We ask the senior if there's anything they have in mind for their session—and sometimes get a request for something they have seen in another student's images.

If you make it fun, by the end of their session, most seniors will be excited about the experience and eager to see their images.

We prefer to have the seniors come back about ten days later to view their portraits.

seen. Try to provide a fun experience. If a parent is in the camera room, get them involved—let them look through the camera, and ask their opinion. Creating some excitement during the session will pay dividends in the sales room.

At the end of the session, ask the senior if he has gotten everything he wanted. Most students will thank you and say, "I can't wait to see my pictures."

Proofs Presentation. Once the session is complete, the next step is the presentation. Some studios do the selling on the day of the session. At our studio, we prefer to have the seniors come back about ten days later to view their portraits.

To present the images, we still use paper proofs, presented in a book with four images to a page. Some studios do not allow their clients to take

the proofs out of the studio, but I think this is a mistake—just be sure the client has left a hefty deposit before they walk out the door. At our studio, we require a $300–$400 deposit (based on the number of session modules the client had). Of course, you must be sure that your customers understand your deposit policy before the deposit is remitted. In our experience, many students go on to buy the proof album with their order.

During the proofing presentation, we again go over the pricing information, print sizes, and finishes so when clients are ready to order, there are no surprises. For most clients, high-school senior pictures are a big investment. The better they understand the process, the more comfortable they will be when they come back in to make their final purchase.

Placing the Order. When the client arrives to place their order, the sales process generally goes smoothly because of everything we have done before this visit. In the sales area, we have four large prints of the same person so the client can clearly see the difference between the various print sizes. This is a great aid in selling larger prints.

Having an employee who is well groomed, nicely dressed, and good at sales is essential if you are going to have above-average sales. People will buy from people they like and trust.

During the sales process, offer suggestions and listen carefully to what the client wants, then simply help them get it. At the close of the sale, thank the client for their business and inform them when they can expect

For most clients, senior portraits are a big investment. Ensuring there are no surprises in the ordering process will help them feel at ease with their decisions.

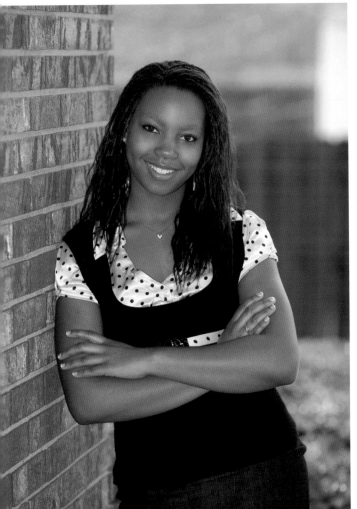

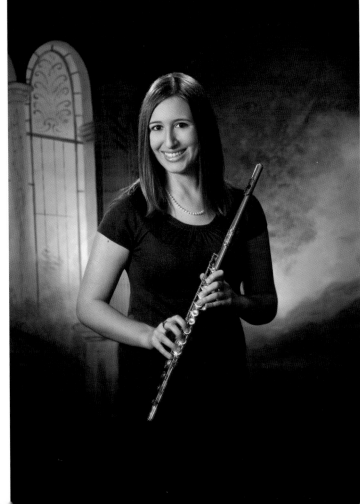

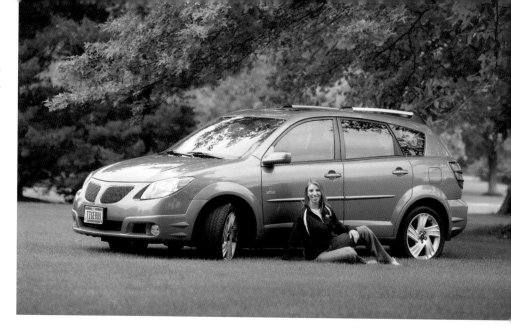

If you do everything right, chances are good that the family will return to you for their future photography needs.

the final product. We require payment for about 75 percent of the final order before it is processed. Most people realize that due to the custom nature of the product, this is not an unreasonable request.

Delivering the Order. In approximately six weeks, we call the client to inform them that the order is complete. Since we do all business by appointment, we set up a time for them to come in. If they have purchased an 11x14-inch print (or larger), we have it displayed on an easel when they arrive. This always creates some excitement for the client. It's all about the sizzle, and this is just another way to add pizzazz to your studio operation!

All of the products the client receives are beautifully packaged, and all photographs are placed in folders or mounted, depending on the size. We carefully go over each client's order to ensure they are completely happy with their purchase. If you have done everything correctly, chances are the next time this family needs photography services, they will call you.

YEARBOOK PHOTOGRAPHY

Working with high-school yearbook advisors for over twenty-five years has given me a little insight into what they want. I have been very fortunate to work with wonderful yearbook advisors. Several years ago, my all-time favorite advisor, Carol Mazanetz from Newton Falls High School, took over a yearbook that was tens of thousands of dollars in debt. Today, the school has a beautiful, debt-free yearbook. I still remember the day back in 1994 when she called us to do the yearbook photography. I hope we have contributed to her success in some small way.

"Service" is the key word when

dealing with yearbook advisors.

"Service" is the key word when dealing with yearbook advisors. They have one of the most difficult extracurricular activities in the school; every year, they must deal with the yearbook publisher, a new crop of students,

the photographer, teachers, and school administration, and, to top it all off, must sell ads to help pay for the book! For them, it is a year-long process, with very little extra pay. The yearbook comes out at the end of the school year or in the fall, then the whole process begins again. Needless to say, with all of this pressure, the last thing they need is a photographer who delivers excuses instead of service.

Sports. Most yearbook advisors want the same thing for their yearbooks: good, clean, sharp images of all of the sports action. We provide yearbook sports photography to several schools, including all the game action from football, track, cross country, volleyball, boy's and girl's soccer, boy's and girl's basketball, softball, and baseball. Photographing sports action takes skill, a little bit of luck, and top-notch equipment.

To get excellent sports action pictures, you need the following equipment: a 35mm digital camera that can shoot at least four frames per second with autofocus, a 200–300mm lens with a f/2.8 setting regardless of what zoom level you are set on, a 28–105mm zoom (again with a constant f/2.8 lens opening), and a dedicated flash system. It is likely that the only time you will use your flash is when you are photographing night

Photographing sports action takes skill, a little bit of luck, and top-notch equipment.

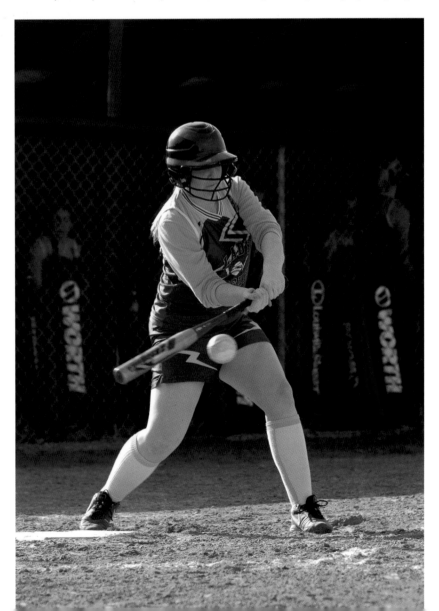

High shutter speeds are needed to stop the action in sports photography.

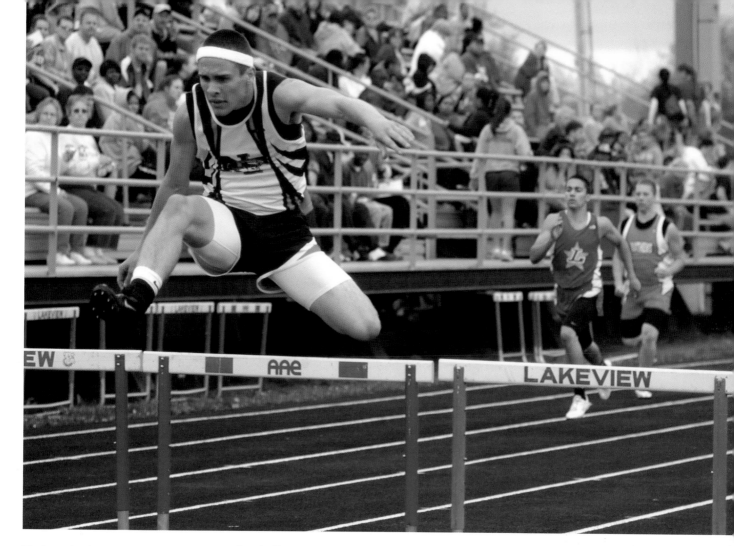

Most yearbook advisors want the same thing for their yearbooks: good, clean, sharp images of all of the sports action.

football games. Using a flash during volleyball and basketball is sometimes prohibited by the referees. Although I don't find it necessary, some sports photographers like using a monopod rather than handholding the camera.

Even with a 1600 or 3200 ISO setting on your camera, the f/2.8 opening is imperative for indoor volleyball and night football photography. Fast shutter speeds of at least $^1/_{250}$ second are needed to stop the action, so you have to gain the light you are losing to the shutter speed by using a large aperture. Sometimes you can stop action with a shutter speed of $^1/_{125}$ second, but I have found that $^1/_{250}$ second works every time. You will use the long, fast lens on all of your game action except basketball and volleyball. Although the long lens works okay for these two sports, a shorter zoom is preferable.

If you have not done a lot of game action work, it is going to take some practice to get good results. Your biggest problem will probably be staying focused on the player or players and not the background. With fast-focusing autofocus cameras, it is very easy to have a player run past your focus point when you fire the camera, giving you tack-sharp spectators and

The yearbook advisor will need images of all the teams, clubs, and other organizations.

Students today want different poses for their team photos.

Be sure to get all of the players—
even the ones sitting on the bench
most of the time.

a blurry subject in the foreground. Like anything else, the more you do it, the better you get.

Something that yearbook advisor Carol Mazanetz taught me was to be sure to get all of the players—even the ones sitting on the bench most of the time. After you have gotten the game action shot with a lot of the main players, get the other players in a huddle or walking on or off the playing field/court—but be sure to get all the players, not just the super-stars. Everyone likes to be in the yearbook, so photograph everyone and let the yearbook staff decide whom they are going to include.

Also, it is best to give the advisors the game action as you photograph it rather than waiting and giving it all to them at the end of the season. With digital photography, it is much easier and more cost effective to give the advisors a CD/DVD of photos from each game. You can quickly delete the poor images and supply only the very best action shots. And don't wait until the end of a season to start covering games. Sometimes outdoor

games will be cancelled due to bad weather, so you want to leave yourself a buffer of time. Waiting until the last minute is usually not a good plan for anything.

Clubs and Organizations. Yearbook advisors will also want you to photograph all the clubs and organizations at the school. Being prompt is imperative, as the advisors will have schedules for each club and organization throughout the day. I know of a photographer who was scheduled to show up at a local airport to photograph the high-school senior class in front of an airplane. The school bused all of the seniors to the airport only to find the photographer didn't show up for the class photograph. (No, he didn't have an accident on the way to the job.) Needless to say, he no longer has the contract for that high school. Photographing the groups in different settings always looks better than just placing them in the high-school gym bleachers. Of course, this will be the decision of the advisor. Prompt, courteous service will pay big dividends to both you and the school.

School Dances. If you will be shooting yearbook images and sports events, chances are, the school will ask you to photograph the proms, home-coming dances, winter dances, etc., as well. A great deal of organization is required to photograph dances effectively and efficiently. I strongly recommend starting out with small dances before you move on to a job with over one hundred couples. Without experience, you are asking for trouble. There are many ways that dances are handled by photographers. I will tell you what has worked well for us over the years.

Planning. When a dance is booked for your studio, the first thing you want to find out is approximately how many couples will be in attendance.

Photographing the groups in different settings always looks better than just placing them in the high-school gym bleachers.

At most dances, many students will want their photographs taken in large groups. We do not photograph any groups until all of the couples have been photographed.

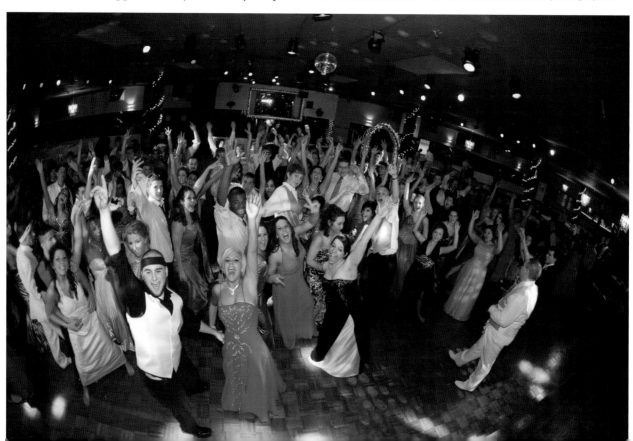

This will determine how many assistants you need and the number of background setups you will require. If 25 or fewer couples are attending the dance, you can handle the posing, taking photographs, and giving change on your own. For 25 to 75 couples, I recommend that you utilize an assistant to give change and direct the couples. When we have a dance with over two-hundred couples, we have up to seven people working to keep things moving so the students do not have to wait in line any longer than twenty minutes. Be sure to bring plenty of change—dollar bills and fives (the bigger the job, the more you will need). For the bigger dances, bring at least several hundred dollars worth of change.

A dance with 200 to 250 couples can be serviced with one background and one photographer, providing you have enough help working the dance with you. As mentioned earlier, several people should work the line, make change, pose, take the dance envelopes, etc., to keep things moving. When photographing dances with more than 250 couples, you will probably need an additional background. The thing to remember here is it's not how many backgrounds you have set up but how efficiently you can photograph the students. A good crew with one background set up could photograph 250 couples quicker than a poor crew with two backgrounds set up. As a guideline for you, with a good crew, we can photograph a couple about every 20 to 30 seconds.

Background Selection. Find out the theme of the dance, as this will give you some idea what type and color background will be most appropriate. We try to use colors that will look good with any color of dress that the girls may wear. Light grays, tans, and other soft colors always look good; bright colors generally do not. Select a background that creates depth. For full-length couple shots, you will need a background that is 10 feet wide by 15 feet long.

Lighting. I recommend using at least a two-light setup. Using only one light will create flat light and simply will not be as attractive. I set my fill light (at f/8) behind the camera and the main light (at f/8.7) off to one side. This gives you an overall reading of about f/11.2 with about a 2:1 ratio on your subjects. Set your camera at f/11 and your shutter speed at $^1/_{225}$ second. (These settings will vary slightly with digital, but they are close. Check the histogram on your digital camera to ensure you have achieved the light ratio you want.) Sometimes, depending on the background, we may use three or four lights on the background. Something I learned from my brother is to direct the traffic flow away from the cords and lights. This keeps the couples moving through the shooting area with less risk of tripping.

The thing to remember here is it's not how many backgrounds you have set up but how efficiently you can photograph the students.

Photographing proms requires both organizational and photography skills. Notice how the subjects in these prom pictures have a pleasing light ratio on them. This is created by using a fill light set at about f/8.0 and a main light of about f/8.7.

Subject Placement. Place the couples about 5 feet from the background. When cropping your subjects in the camera, be sure to allow some space at the top and bottom. Having the subjects' heads too close to the edge of the frame will not look good.

Lens Selection. You will want to use a normal lens for this type of photography. Long lenses require you to work so far from the subjects that, many times, they can't hear your instructions.

Blinks. If you are shooting the job with film, you'll want to be sure that you have no blinks recorded. Have your assistant watch one student while you watch the other one. If you see a blink, of course, you will want to take the picture again. If you are using a digital camera, you can check for any blinks on the LCD screen.

Group Pictures. At most dances, many students will want their photographs taken in large groups. We do not photograph any groups until all of the couples have been photographed. This is clearly indicated on the price list and envelopes that the students receive at the school. The reason for this is that it takes more time to photograph a large group than a

Long lenses require you to work so far from the subjects that, many times, they can't hear your instructions.

couple. Also, you would have to keep moving the main light backward for a group and closer for the couples, and this would slow down the job.

Include a separate package on your price list for group pictures. We charge $8.00 for each person who wants to buy the picture. We do not charge students if they are in the picture but don't want to purchase it. Not everyone who is in the picture is going to buy it. Group pictures at school dances can generate several hundred dollars in sales.

Candids. More than likely, you will also want to take candid photographs of the dance for the yearbook advisor. Try to get as many students as possible in the pictures you create. Remember, everyone likes to be in the yearbook.

End of the Shoot. Always have the disc jockey announce a last call for pictures before you start to take down your lights. Before you leave for the evening, be sure to contact the teacher in charge of the dance to let her know when she can expect the pictures to be delivered to the school. Our normal delivery time is about three weeks. Package the pictures neatly, and put them in alphabetical order so they can be passed out easily to students. Remember, just about everything goes back to service.

Staying Open the Night of the Dance. Many times, a photography studio close to the dance location will open on prom night, hoping that the students will have their pictures taken at their studio instead of at the dance venue. The studio owner has students pass out flyers stating that they will be open on dance night.

Although you may get some students to come into your studio, this can backfire on you much later.

Although you may get some students to come into your studio, this can backfire on you much later. If and when the school is looking for a new photographer, any ill will you created with the school by opening your studio on dance night reduces the chances you'll be considered for the contract. If you have no desire to be considered for a school contract then, by all means, open your studio on prom or homecoming night, and get as much business as you can. If you are getting the students photographed quickly, chances are you will be photographing most of the students at the dance—if not all of them. Don't give the students a reason to go anywhere else.

One Studio or Several? Some school administrations make it very difficult for the yearbook advisor to produce a quality yearbook. He or she must try to get photographs from many different sources to put out a quality book. I think most school yearbook advisors would agree that they would rather deal with one photographer than four or five different ones. If you get the opportunity to work with a yearbook advisor, therefore, be sure to give them excellent service all the time.

When dealing with a high school, be sure to find out exactly what is expected of you and what you will get in return. We were once hired by a high school to do the individual sports packages and all the game action images for sporting events, and to photograph all of the clubs and organizations for the yearbook, as well. The job of photographing the school's two dances, a much more profitable assignment, was being handled by another studio, whose responsibility it was to show up one night, photograph the dance, count the money, and deliver the pictures three weeks later. We, on the other hand, had to constantly haul our equipment to the school to photograph various groups and events.

Difficulties that arise in multiple-photographer situations are generally due to a lack of communication, caring, or understanding between the yearbook advisor, school administration, booster clubs, and the various teachers involved with the dances, sports, etc. You may want to agree to an arrangement like this in hopes of getting the entire job or until another school calls you for all of their activities, but be aware that such a job may present some drawbacks.

Contracts. A contract is an agreement between a photography studio and a high school. You provide sports, dance, club photographs etc., for the school, free of charge, and in return, you get to photograph all of the packages that the sports and band students purchase. In addition, you are given the privilege of photographing the prom and homecoming dances. Of course, you don't want to give away the farm—remember, you are in business to make a fair profit.

When dealing with a high school, be sure to find out exactly what is expected of you and what you will get in return.

OOPS!

With so may people running the show, something is bound to go wrong. For example, I was recently hired by the athletic director of an area high school to photograph the basketball team and cheerleaders on a Wednesday night. What he did not know, however, was that the president of the basketball boosters club had hired someone else to photograph the same students at a different location on the previous Saturday! The booster-club president hired the other photographer because he was cheaper and, of course, she assumed the quality and service would be the same. We still ended up photographing about half of the students, but can you image what the parents and students thought about the school's ability to organize a simple thing like a basketball photo shoot?

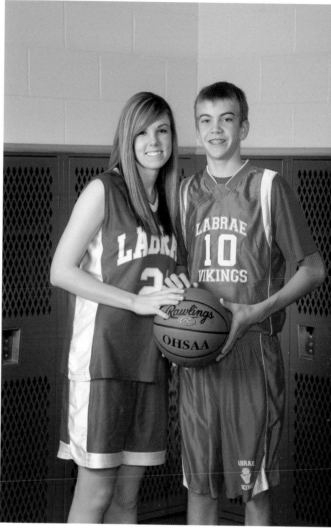

What you may be expected to deliver can vary widely from school to school. Before entering into an agreement, be sure you understand all the details.

Believe me when I tell you that what these contracts entail varies greatly from school to school—both in terms of what you are expected to do for the school and what you will get in return. For instance, some schools photograph yearbook pictures for free as part of their contract. However, I've chosen not to engage in such an agreement. While there are pros and cons to offering this service (you photograph all the seniors for free but increase the likelihood of winning the students' business when it comes time for a paid session), we really don't want seniors coming to us because they feel they have to. We want to cater to a higher-end clientele who want a high-quality product with superior service.

Coordination. In some schools, the athletic director, band director, prom advisor, homecoming advisor, multiple coaches, and even the booster club president will each hire a photographer to cover their event(s). The yearbook advisor tries to get all of the photos they need from a variety of

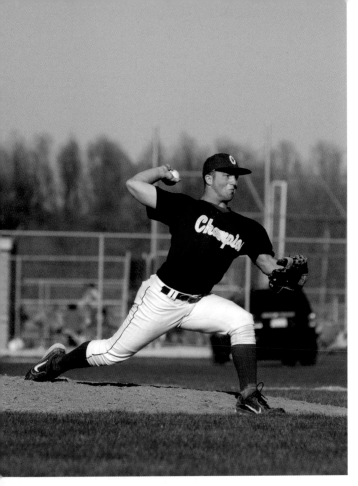
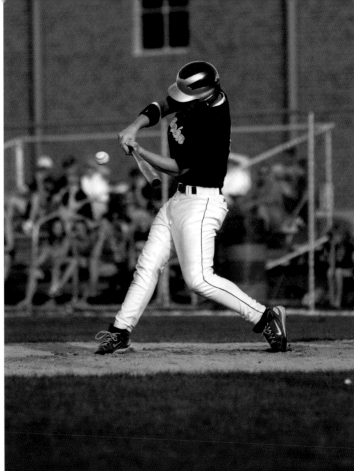

photographers, which is a difficult task. You will not usually have these problems at a high school where the yearbook advisor has been on the job for many years. When jobs are broken down in this way, the profit that any given photographer can expect is diminished. You will have to decide if a particular school contract will be profitable. This is a somewhat complex issue. If you are the only studio the school is using, it's probably worth it. If you are just getting a couple of small assignments from the school, it may not be worth your time. Don't get caught in the trap of doing all the free work for the school hoping they will someday call you for the profit work. At two of the schools we service, everything works fine. Unfortunately, they are the exception rather than the rule.

The Advisor. The yearbook advisor's job is usually one of the least desired positions at a high school. Many times the administration will require that a new teacher getting hired take the yearbook position as a condition of employment. The other extreme you usually find is a teacher who has had the job for years and has everything down pat. Whether the school hires a single photographer or multiple photographers, the advisor's goal is the same: to produce a superior yearbook each year.

Requirements. The yearbook advisor is going to want excellent photography of all the sports game action that occurs throughout the school year.

ABOVE AND FACING PAGE—A commitment to photograph a school's team sports can require a lot of your time to fulfill.

To photograph all of these sports requires a great deal of time, equipment, and talent on the part of the photographer.

You will also be called upon to photograph the senior class on the school grounds or at an off-site location. I have been on rooftops, up in cranes, and in all sorts of places to produce a unique senior class picture.

Additionally, you will need to photograph all of the clubs, organizations, etc. This usually takes a full day at the school. Candid pictures of the school dances are part of the yearbook as well. Pictures also are needed of the school board members, individually and as a group; teachers; secretaries; plus special sports and Hall of Fame functions; band parents' nights; sports parents' night; the list goes on and on.

Landing a Contract. Most of the contracts we have acquired over the years have been the result of poor service from previous studios. This type of photography is very political. My brother operated a studio about seventy-five miles south of ours. He lost a contract one year because the yearbook advisor started dating one of my brother's competitors. My brother's chance of keeping that school contract was slim to none, and slim just left town!

Do not depend on this type of work for steady income. You never want to have your main income at the whim of a booster president or a new athletic director. Most of the time the person choosing a photographer will choose strictly on price—they assume that the quality and service will all be equal! Knowing the right people certainly does not hurt. Remember, it's okay to get the job because you know someone, but you must still provide a top-notch product with superior service.

Most of the contracts we have acquired over the years have been the result of poor service from previous studios.

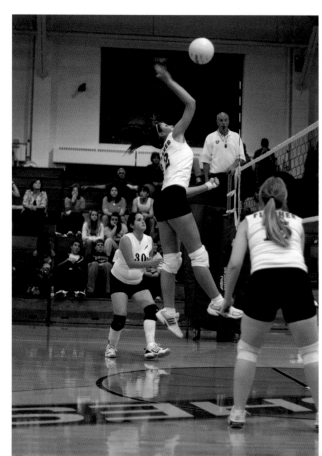

SPORTS LEAGUES

Sports league photography is probably one of the most competitive genres. As with most professions, the lower the skill level required, the more competition you are going to have. The photographic skill set required for most sports photography leagues is quite basic. Many part-time photographers try to acquire this type of work because you don't need a studio or advanced lighting and posing skills.

Organizational skills, on the other hand, are a must when photographing a large sports league. Don't even think about taking on a large league of several hundred players until you have the confidence and staff to make everything go smoothly. Most large leagues have a board made up of several parents. Their job is to run the league, acquire uniforms, schedule games, and try to keep parents who think their child is a superstar happy. For the parents running the league, it's a labor of love. They spend many volunteer hours making sure the kids and parents enjoy being in the league.

Many times, somebody on the board will recommend someone they know to do the league pictures, so knowing the right people doesn't hurt.

Sports league photography is probably one of the most competitive genres.

ABOVE AND FACING PAGE—Photographing sports leagues requires a lot of coordination—don't even attempt to take one on until you have the confidence (and staff!) to make things run smoothly.

If you get the opportunity to present yourself to a board, be brief and to the point with your presentation. Remember, these people are there on their own time. Show them a few pictures and your prices. What you are really selling is yourself. If they don't like you, you are not going to get the job—it's just that simple. The main concern for parents is price. They couldn't care less about any of your awards for beautiful pictures. Basically, what they want is decent pictures, low prices, kids not waiting in long lines, and a fast turnaround time on getting the prints back.

Offer a large variety of packages and various sports trinkets. Plaques, balls with pictures on them, trophies, trading cards, etc., are popular with the kids and their parents. They also provide you an opportunity for additional profits. Be prepared to offer a percentage of your gross back to the league. Most of the larger leagues expect at least 10 to 20 percent of your gross as a kickback. Find out what they want before you accept the job so that you know how much to raise your prices. You certainly don't want the 20 percent coming out of your profits!

Once you have been offered the assignment, you will want to get a schedule from the league for picture times for each team. Get your picture order forms printed and delivered to the league several weeks before the

Allow yourself plenty of time to photograph not only the teams, but also each of the team members individually.

job. If you are going to be photographing indoors, get the phone numbers of several people who can let you into the building. If the person is late unlocking the door, you will be the guy blamed for running behind all day. Have backup phone numbers and expect the unexpected. Remember, you are dealing with volunteers. They have no idea it might take you one hour or more to set up backgrounds and lights, test cameras, and set up trinket displays. If you are doing the photography outdoors, have a backup plan in case of rain. Again, you will need contact people and phone numbers. Nobody is going to make this happen for you. If something does not go correctly, whether it's your fault or not, you will be blamed.

If you are doing the photography outdoors, have a backup plan in case of rain.

Allow yourself about ten to fifteen minutes to photograph each team. Since we are located in a small town, none of the leagues have more than four- to five-hundred players. On picture day, we have one person photographing the individuals and another photographing the teams. You will

also need a person collecting the envelopes and someone posing the kids. Have a large poster of several different poses the kids can choose from— or, if you are really quick, shoot two or three different poses of each player and choose the one with the best expression. Stay organized and have enough help to keep things moving.

After the photography, getting the correct packages printed is very important. You don't want parents calling you after the packets have been delivered complaining they didn't get what they paid for. If you are shooting the job digitally, there shouldn't be any blinks—but you may still have a few parents who want a retake for various reasons. Therefore, you should have a picture retake day set up with the league before the packets are delivered. Usually we just have the very few kids who want a retake come to the studio. It's the most flexible solution for everyone involved.

Sports league photography is not for every photographer. You are dealing with young children and their parents. Therefore, you will need to be pleasant, have fun with the kids, and above all have an excellent, experienced staff to keep things running smoothly and to deliver the finished product on time.

WEDDINGS

Wedding photography is a common entry point for those looking to dive into photography as a career.

Like many other photographers, one of my first paid assignments was photographing a wedding. For those getting into the photography business, weddings are generally the first step, as all you need is a camera, a flash unit, and hopefully a backup system.

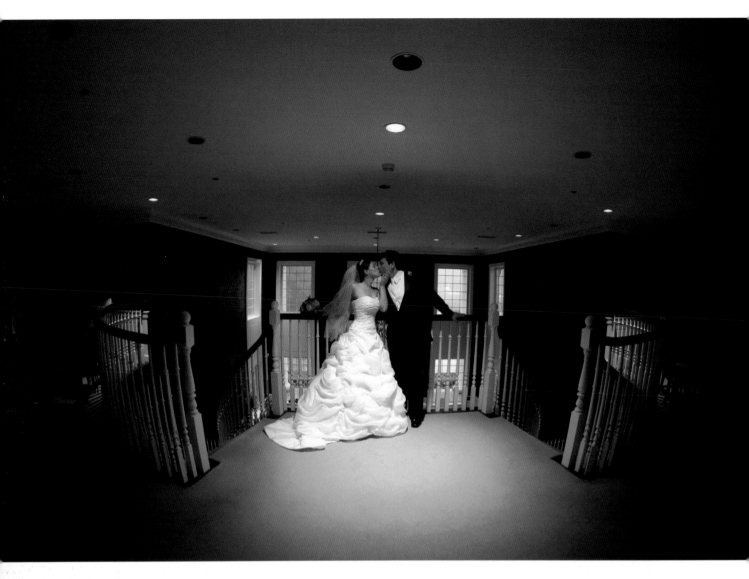

On the other hand, it's not unusual for a photographer to stop doing weddings once they have enough other work to keep the studio busy. I find it rather strange that weddings are the first thing many photographers start with, but it is also the first thing many of them stop doing. For some photographers, it's almost like a badge of honor to be able to say, "I no longer photograph weddings."

Weddings are not for everyone, that's for sure. Why do some photographers love doing weddings, while others quit the moment they have enough other work? Having excellent photography skills is only a small part of being a successful wedding photographer. In this section, I will explain what works for us.

The Type of Client. As I have mentioned throughout this text, you need to determine the type of client you want to attract. Whether you are

ABOVE AND FACING PAGE—When it comes to booking a wedding, the photographer's personality is perhaps even more important than his portfolio. On her special day, the bride will want to share her time only with someone she genuinely likes.

doing fire hall/VFW-hall weddings or country club and high-end hotel weddings will be determined by many factors. Price, photography skills, studio décor, phone skills, and service will all play a big part in the type of clients you attract. Don't forget: you must have a very pleasant, likeable personality to convince the bride you are just the person she is looking for. If she doesn't like you, she'll never book the wedding with you, regardless of how beautiful the photography is.

Telephone Skills. Almost all wedding bookings start with the telephone. Of course, we already know that good telephone skills are essential—not only for weddings but across the board. You simply must have a person with excellent skills on the telephone.

When a bridal client calls, the first question they usually ask is how much you charge to photograph a wedding.

When a bridal client calls, the first question they usually ask is how much you charge to photograph a wedding. I believe they don't know what else to ask, so they start out with the price question. Many times they will ask for a price before they even know if you are available!

We'll assume that you are not a low-end wedding photographer and that the prices you are charging are for the average to higher-end client. The best way to deal with a wedding call is to engage the caller with questions about their upcoming wedding. Our end of the conversation with our prospective wedding clients goes something like this: "Congratulations, Lisa, on your upcoming wedding. What is the date? Where are you getting married? Where will the reception be held?"

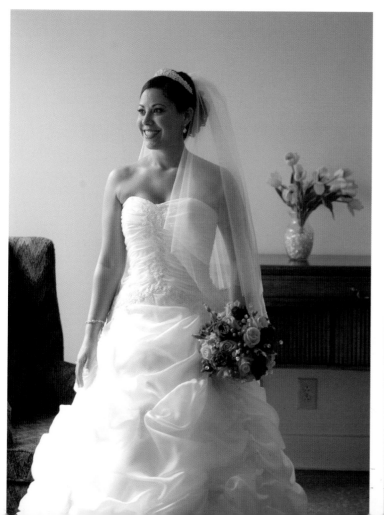

By engaging the caller with questions, you can determine if they are going to be interested in your services. If they are calling in response to your Yellow Pages ad, chances are they will select a wedding photographer based on price and nothing else. They are looking for what I call the "BBD" (bigger, better deal). Quality and service are not important—they just want the cheapest photographer they can find.

On the other hand, when a bride calls and does not ask about pricing but wants to come into your studio to view your work and meet with you, chances are she is serious about professional wedding photography. Her main concern is not price but quality—and your reputation. These are the clients you want.

Consultation. When the client comes into the studio, show them two or three completed albums. We use flush-mounted albums from Capri Albums from New York for our studio samples. They are very upscale and beautiful. While the client is viewing the albums, point out what makes your photography worth your higher prices. Photo examples of excellent posing and natural lighting should be present in your studio sample

By engaging the caller with questions, you can determine if they are going to be interested in your services.

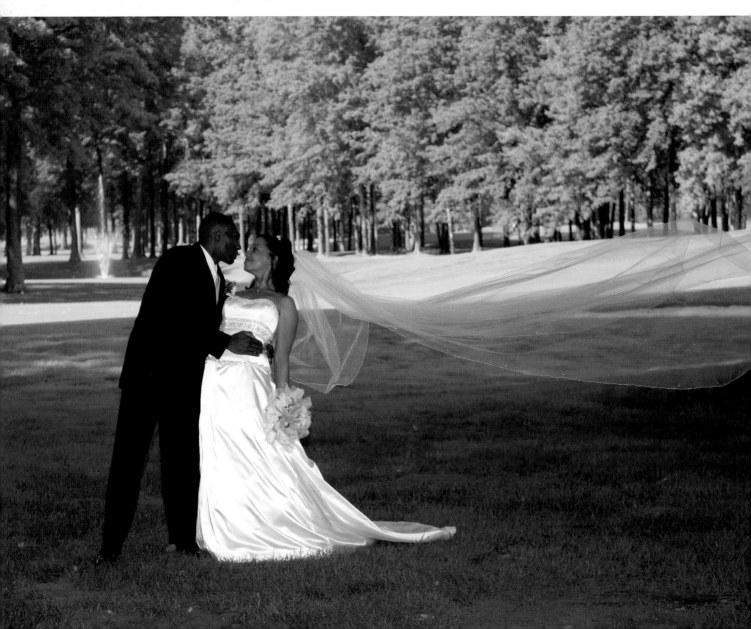

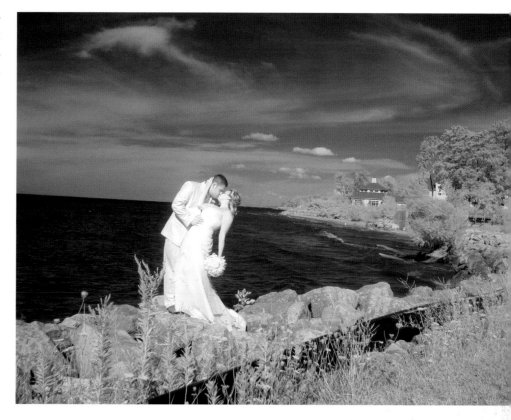

If the bride decides she wants

to book you, be certain that she

fully understands all of your payment

procedures and policies.

albums. After all, if the client can't see what makes your pictures different from a lower-cost studio's images, then there is no reason for them to pay the difference. Since all brides are different, find out what type of photography the client likes best and focus on the work that suits her tastes.

If the bride decides she wants to book you, be certain that she fully understands all of your payment procedures and policies. Try to keep it all very simple. Clients get uneasy about any transaction they don't fully understand. On a related note, be sure to take notes on anything that you will need to know on the wedding day. Issues such as divorced or deceased parents are things that you should be aware of ahead of time.

We require approximately 15 to 20 percent of the total price as a deposit or retainer to hold the date. Any refunds are handled on an individual basis depending upon the circumstances, and I can honestly say that, at our studio, cancellations are rare.

About a week prior to the wedding we call the bride to confirm everything. We remind her of the times that have been agreed upon and emphasize to her that being on time will make everything less stressful. The key to a good day with a bride is giving her as much information as you can. You know from experience about how long everything will take and how to make things run smoothly.

The Wedding Day. I photograph weddings with an assistant. You certainly can do it on your own, but why knock yourself out? My assistant works on the candid photos while I concentrate on the posed ones. It's a good combination and a good way to offer a better product.

Before the Ceremony. On the day of the wedding, my assistant and I arrive approximately fifteen minutes before the agreed-upon time, dressed in black tuxedos. The vehicle that we arrive in has been cleaned, and we look totally professional. Image is everything!

When we arrive at our first destination of the day, I look for areas where I can photograph the bride with window light. Use your flash as little as possible: this will separate your work from the competition.

The Ceremony. During the ceremony, having an assistant gives you the opportunity to photograph the wedding from different areas of the couple's venue. We have some beautiful photographs where the bride and groom are coming down the aisle after the ceremony—I shoot images

Often, my assistant takes a shot like this from the balcony. Shooting with an assistant during the ceremony is important, since you can't be in two places at once!

from their level, and my assistant takes the same shots from up in the balcony. I just don't think it's possible to cover a wedding as well with one person as you can with two.

After the Ceremony. After the ceremony, we generally do the posed photographs of the family members. I find it best to start with the grandparents, then photograph the parents and family members, and then handle any other special groups the bride and groom may want photographed. We finish this sequence with photographs of the bride and groom. Keeping things moving and being quick is the key. Depending on the size of the wedding party, you should be able to do all of the groups and bride and groom shots in about forty-five minutes.

After the ceremony, many couples want to go to an outdoor location for more photographs. To make your outdoor photographs look their very best, be sure to use a long lens so that the backgrounds will be out of focus. This will make the bride and groom really stand out.

The Reception. Once you get to the reception, most of the hard work is behind you. Most receptions last at least three to four hours, and we usually stay most of the evening, since our pricing is set up to cover a ten- to twelve-hour day. Many studios charge by the amount of time the bride has booked. Although there is certainly nothing wrong with that practice, I have never charged that way; I think it would just cause problems—after all, anyone who has done their fair share of weddings knows that things usually do not go as planned time-wise. I don't want to have to approach the bride during the reception and remind her that she only booked us for the eight-hour coverage, so we will be leaving shortly.

I know of one photographer who stays for only the first thirty minutes of the reception. Of course, the bride knows all of this beforehand, and the photographer arranges for her to get everything over in the first thirty minutes—the toast, dancing with dad, cutting the cake, you name it—just so he can go home early! If it's working for him, great. I know one thing for sure: if my daughter went shopping for a wedding photographer and he told her he would be leaving the reception after thirty minutes, he wouldn't be hired.

Lens Selection. I recommend that you have available several different types of lenses to use during the wedding day. Use lenses that the amateurs at the wedding probably don't own; using a very long lens or a fish-eye lens, for instance, will make your photographs look different than all the rest. You do not want your pictures to look like they were taken by the guests. Creating unique photographs will pay dividends later when the bride orders her final album.

After the ceremony, many couples want to go to an outdoor location for more photographs.

One way that we ensure that our images stand out from the rest is by using double lighting. Double lighting requires two flashes, a radio transmitter, radio receiver, and a light stand (or better still, an assistant). To create this look, simply hook up your on-camera flash to a radio flash transmitter. Your second flash, which can be up to one hundred feet away, should be wired to the radio flash receiver. When you push the button on your camera and your transmitter is turned on, it fires the flash on the camera and sends a signal to the receiver, and the second flash goes off as well. Having an assistant hold the light and move it around is better than

When a great location, flattering posing, and lovely lighting all come together, you can be assured that the bride will be happy she chose you to photograph her wedding!

putting it on a light stand. You can create some really neat effects using this system. You can backlight a couple at a reception or light a large hall, which can be difficult with just one flash. You control both lights from the camera and can fire just one or both, simultaneously. Most major camera stores carry the equipment needed to double light. Be aware that achieving good results will take practice and a thorough understanding of your flash equipment. One final tip: be sure that both of your flash units have the same output. This will make things much simpler.

After the Wedding Day. Good service is just as important as good photography in the wedding business. Regardless of how you are showing your images, they should have their proofs or CD/DVD within three weeks. Once the order is placed, be sure to deliver it within twelve weeks.

Pricing. Wedding photography can be very lucrative if it's properly priced. Unfortunately, the wedding industry is filled with photographers who give us all a bad name. If you are going to be a serious player, you need to learn as much as you possibly can about posing, lighting, and customer service. To make serious money, everything must be top notch in your operation. You want people to be proud when they say, almost bragging, "Williams Photography is photographing my wedding!" Building a reputation takes time, but it will be well worth it. Whatever pricing strategy you decide on, it's a good idea to have a statement on your wedding contracts noting that your current prices are not good forever. I have had wedding clients come in five years after their wedding to order pictures.

In my experience, you'll have more problems with wedding clients than any other demographic—and most of the time, it's the parents (who were never in the studio before the wedding to discuss prices, procedures, and delivery times) who cause the problems. If the bride and groom both have divorced parents, you can actually be dealing with four, five, or even six individuals, each with their opinions on what you should be charging! Be sure to have everything in writing.

FAMILIES

Photographing families is the most profitable aspect of our business. Unfortunately, we just do not get enough calls to offer nothing but family portraits. Church directory companies can make it difficult for a studio to compete when it comes to family portraiture. For most people, price is the main motivator in choosing a family photographer, and for this reason, a lot of family photography is done by church-directory companies. However, there are clients who value quality over price and will pay for a premium family portrait.

If you are going to be a serious player, you need to learn as much as you possibly can about posing, lighting, and customer service.

To stay competitive in this area, be sure to offer services that clients can't get from church directory companies, such as photography sessions in the family's home. With this type of session, you can show your digital images using a laptop and projector immediately following the shoot, when excitement over the session is still high. Remember, to sell big, you must show big. You will have an easier time selling a large print when you project a 20x24-inch over their fireplace immediately following the session than you would if you were to show a 4x5-inch print two weeks later in the studio.

Consultations. When a client calls our studio to book us for a family portrait, we suggest that they come in for a consultation. We have brochures that we give to the family members to ensure they will be dressed properly for their session. We discuss with them the different print sizes and finishes that we offer, and we suggest they locate an area in their home where they think they will want to display their family portrait. We also ask them to consider the type of frame they may want to purchase. Making this effort before the session enhances the clients' interest and gets them excited about how good the photograph is going to look when it's displayed in their home.

We have brochures that we give to the family members to ensure they will be dressed properly for their session.

Basic Goals. On the day of the session, we will do at least two different poses of the entire family group. The main thing to shoot for is getting the right expression on everyone's face. It's also a good idea to break the family into smaller groupings. Photographs of just mom and dad and just the children will usually increase your sales.

Presentation. In my experience, projection is definitely the best way to present your family portraits. With the new video projectors today, you don't even need a large, darkened room to create an impressive show. These units project a very bright image, even in a lighted room. By projecting, you can quickly show your clients different sized photographs. Start the projection process by showing very large wall portraits. Most of the time the client will say that the image is too large. When you come down a size or two, though, you are still showing a 24x30- or at least a 20x24-inch print. Showing the client a 4x5-inch paper proof and trying to sell a larger photograph is very difficult. Projecting your images all but guarantees the sale of a larger print.

Keep in mind that families investing in portraiture are spending discretionary income. Therefore, to maximize the sale, everything from the phone call down to the delivery of the final product should be top notch. Your main competition for this kind of spending is not other photography studios but other businesses selling luxury items that none of us really need. Look around and take notice. Most businesses selling luxury items are polished, well-run operations. Jewelry stores, luxury car dealerships, and hotels are excellent examples. In these businesses, you'll see that everything is geared toward the luxury buyer. Photography is certainly no different.

Church Directory Companies. Church directory companies operate much like high-volume underclass school picture companies. They go from town to town and photograph families in churches for free (the church probably gets a kickback).

Keep in mind that families investing in portraiture are spending discretionary income.

To maximize the sale, everything from the phone call down to the delivery of the final product should be top notch.

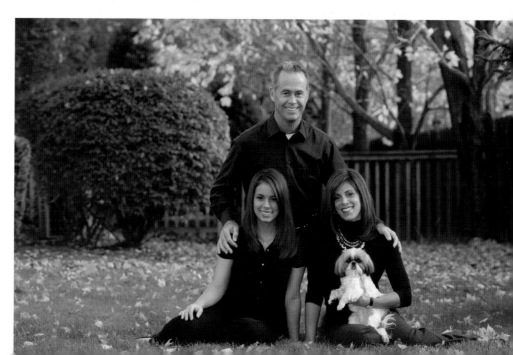

These directories usually feature a photograph of each family grouping, along with name and address of each group. These booklets also typically include some photos of the church and a little written history. The bet is you will be so happy with the family portraits that you will buy photographs for yourself and all your family members.

Generally, the companies set up in two rooms and photograph families by appointment. Once the clients are photographed in the "camera room," they move into the sales room. The salespeople who work for these companies are usually commissioned and have their presentation down pat.

Needless to say, this type of photography is slightly better than nothing. The lighting and posing is poor, there's no retouching, and the pictures are cheap (and cheap looking). These companies operate on volume and do the selling right after the session while the excitement over the session is still at its peak. For most families, this will be the only family portrait they will ever have.

Meet with the interested party before committing to do this type of work . . .

PRODUCTS

Product photography is a very specialized genre. Although we do not advertise for our product photography services, we are occasionally called to photograph a building or product, or to take photographs for insurance claims. I recommend that you meet with the interested party before committing to do this type of work to find out exactly what it is that they want. Also, be sure to get a portion of your fees up front.

8. MARKETING IS KEY

Ideally, about 10 percent of your gross income should be invested in your marketing campaign. Determining where to put your hard-earned advertising money is a challenge. We have tried about every type of advertising you can think of. We have done radio ads, movie theater ads, mall displays, all sorts of different mailings, video shows at high schools, yearbook ads, football, soccer, and basketball program ads, Yellow Pages, phone book cover ads, web site ads—and the list goes on. I even had a salesman try to sell us ads that would go onto grocery carts! I learned the hard way that anyone who is selling advertising will tell you anything to get you to spend money with them.

In this chapter, we'll look at some of the basic components of advertising, then we'll delve into some of the advertising strategies we rely on to reach our target clients.

I learned the hard way that anyone who is selling advertising will tell you anything to get you to spend money with them.

Once you've determined the types of clients you want, how do you get them into your studio?

BASIC MARKETING STRATEGIES

Planning your marketing in January for the year ahead will pay big dividends if done properly.

Get a large yearly planner from an office supply store. Mark on the calendar all of the start dates for your major promotions. Dates like Valentine's Day, Easter, promotions for weddings, high school seniors, etc., should all be marked. Determine the dates that you would like to have your clients receive your materials. Be sure to factor in things like print times, assembly, delivery of the mailers, etc., when establishing your advertising schedule. I recommend that you give yourself at least a couple of months to work on your promotion and for your printing company to produce your materials.

Be sure to factor in things like print times, assembly, delivery of the mailers, etc., when establishing your advertising schedule.

SPEND THE TIME AND MONEY

Good advertising does not just happen. It takes a lot of time and capital. Remember, it all goes back to what type of clients you want to attract. The advertising materials your client receives sends a powerful message as to what type of studio you are. Be sure all of your brochures look and feel expensive. Look at brochures from other types of businesses for ideas on paper stock and layout.

I would suggest spending at least one day a week working on your marketing. I have visited many studios, and the ones that are really successful all have one thing in common—they advertise frequently. Good marketing is not an expense, it's an investment.

CREATE A SENSE OF URGENCY

When you design your mailer, be sure to have some sort of a deadline on your mail piece. This will create a sense of urgency for the recipient to act quickly on your offer.

That said, let me point out that the whole point of running a promotion is to get clients through the door. It's not a good idea to turn someone away just because they called for an appointment a couple of days after a promotion has ended. When a client calls to inquire about a promotion that has recently ended, we tell him or her, "The promotion you are calling about ended last Friday, but if you can come in within the next week or two, I will gladly extend the offer to you."

QUALITY COUNTS

When creating your mailers, be sure that they are high quality, printed in color and on high-quality paper stock. The quality of your mail piece will reflect the image you want to convey.

Direct mail is a common marketing strategy used to attract senior-portrait clients.

Direct Mail. The most effective form of marketing for a photography studio is direct mail. These advertising pieces are usually sent out third class via a bulk rate permit. If you will be doing a large number of mailings, you may want to look into obtaining your own permit. Otherwise, you can take your mail to a bulk rate center and use their permit. We used to do all of the work ourselves, putting the labels on the envelopes, stuffing the envelopes etc., but found it was much more cost effective just to take it to the mailing house and have them do all of the work. Be sure to give them about a week to prepare your mailing. If you have a time-sensitive piece, you want it to arrive on time.

Direct mail is an effective form of advertising for the majority of businesses—that's why we all receive so much of it. Any studio that is doing any volume at all does a lot of direct mailing. I can honestly say that anytime we mail out a promotional piece we make money from it.

The client response rate to direct mail will vary depending on the time of year and the promotion you are offering. You should know that the industry standard for direct mail response is about 2 percent. If you send out 3000 pieces and get a response from about 60 clients, your direct mail campaign was a success. Don't waste your time sending 300 to 400 pieces.

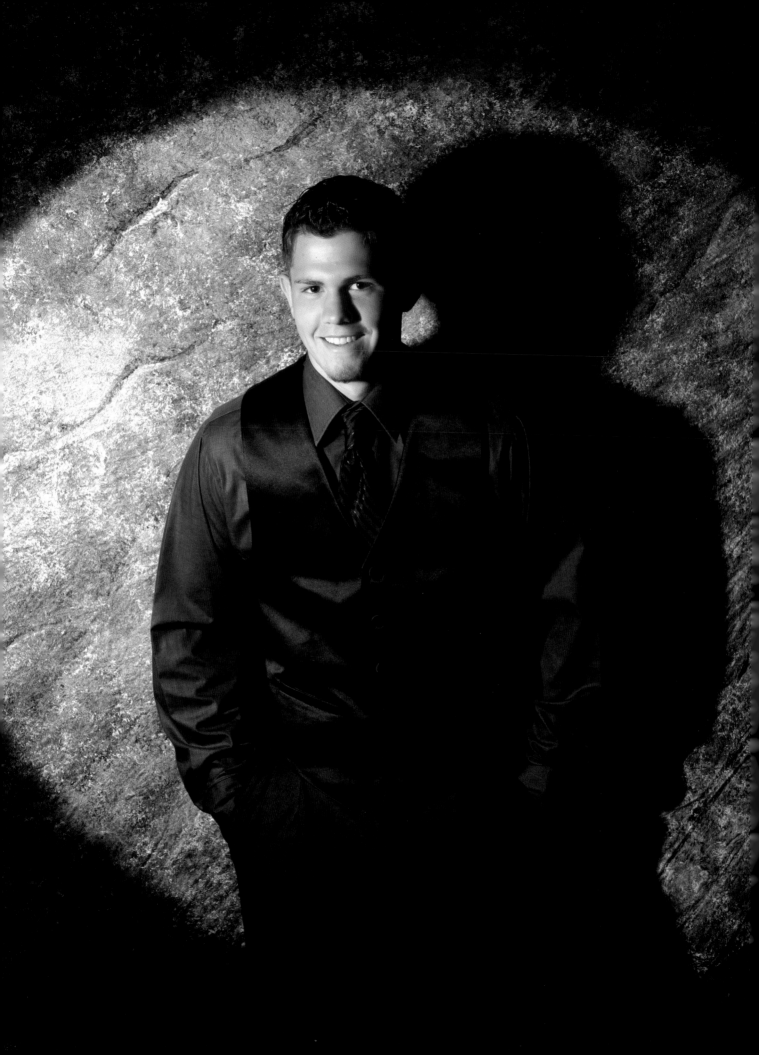

MODEL RELEASES

Be sure to get a model release form from everyone whose image you will be using in any of your marketing material, including your mall display. If you plan to feature images of minors, be sure to have the subject's parents sign a parental consent form as well.

In my opinion, you need to send at least 2000 mailers to ensure an effective campaign.

Mall Displays. A mall display can provide you with excellent exposure and create some excitement for your clients. We have had a display at the major mall in our area for over seven years. Although it is fairly expensive, we find that it is worth the cost. Our display is not that large, but it is well lit and is in a very good location.

To get the ball rolling, contact the mall manager about setting up the display. Have some sample photographs with you and a photograph of your display so that the manager is aware of what you have in mind. They tend to be fussy about the size, height, etc., of your display. You also will be required to have liability insurance. Have literature pockets on the bottom of the display. Also, be sure to keep the pictures fresh. We try to change ours photographs about every six weeks.

Your Web Site. Today you must have a presence on the Internet. Your web site allows clients to access information about your studio 24/7.

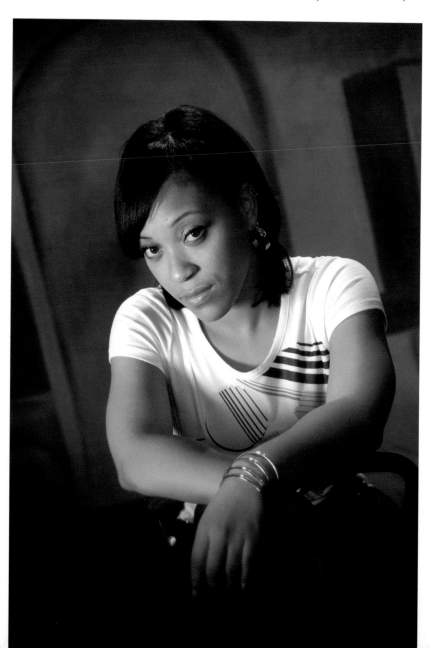

RIGHT AND FACING PAGE—Kids love to see images of themselves and their friends in mall displays.

Remember, you only have one chance to make a strong first impression. Be sure that your site's design is user friendly and features strong, up-to-date images that reflect your studio's portrait style. Also be sure that the overall feel of the web site has the same tone as your other marketing pieces and the mood you've created in your studio. If your portrait style is more subdued and traditional, you might consider featuring classic portraits, more "serious" colors, and classical music. If your studio is cutting edge, you might choose trendy images and more energetic music. There are many companies that provide royalty-free music for use on web sites. A Google search will produce plenty of leads. Be sure to update your site regularly with new images and promotions.

Social Networking Sites. Networking with customers via Facebook, Twitter, and other web sites is really not optional anymore for business owners—it's pretty much a fact of business life today. Just a couple of years ago, MySpace was big, but now Facebook is the top choice of photographers establishing a presence on social networkings sites so they can markt to high-school seniors. Some photographers claim that over 90 percent of their business comes from their Facebook presence. It goes without saying that you'll want to have links on your web site to Facebook and Twitter.

Facebook lets customers and potential clients know your business on a personal level. Clients come to you for a relationship. It's a known fact

BELOW AND FACING PAGE—Increasingly, social networking sites like Facebook are influencing people's buying decisions.

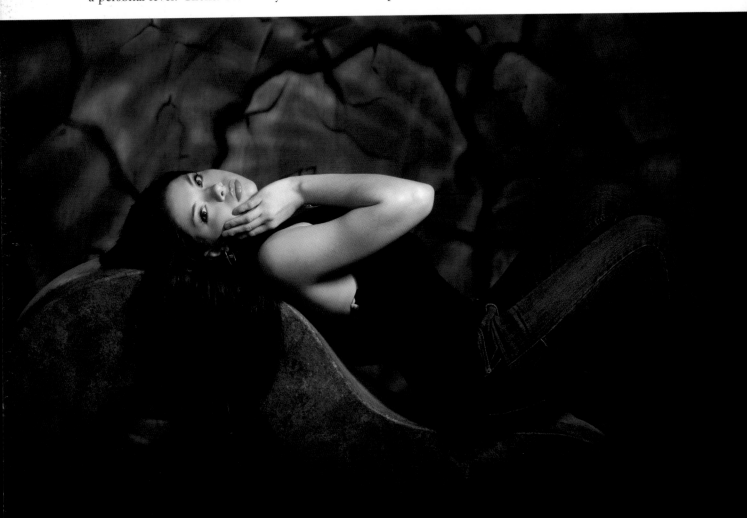

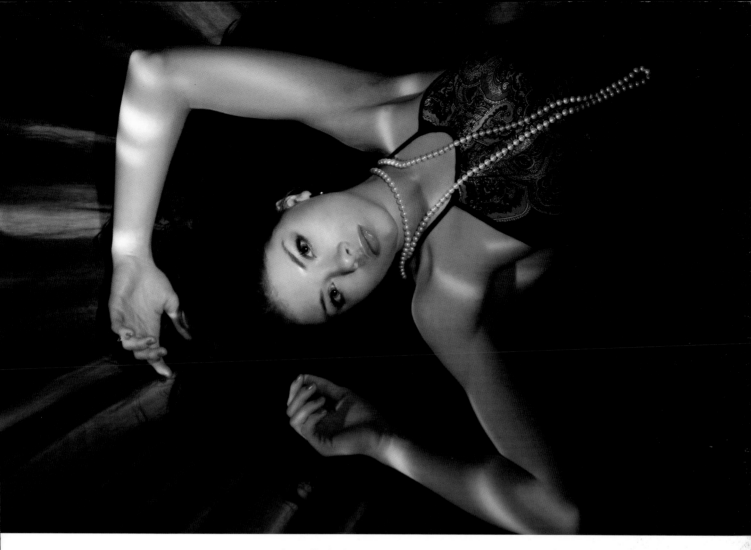

people will do business with people they like, and being accessible on social media sites helps your clients and customers feel connected to your company. Involve customers in your efforts. With their permission, regularly post testimonials from current or past clients. These posts can be part of a frequent and consistent plan to keep your Facebook presence fresh. Expect to devote an hour or two per week to maintain your pages.

Word of Mouth. The quality of service and product you provide and the professionalism of your employees will determine the type of client you will attract—and the number of calls you get for service. The fact is, photography is very much a "people business." If a high-school senior isn't happy with their photographs or the service they received from you, chances are his older sister won't call you to photograph her wedding.

Yellow Pages. In my opinion, the Yellow Pages are one of the least effective means of advertising. The salesperson will tell you that Yellow Page advertising is the end all and be all of marketing, and the larger the ad you purchase, the more the phone will ring. Don't believe it! It's easy to spot new photographers in town. Just look in the phone book for the

In my opinion, the Yellow Pages are one of the least effective means of advertising.

largest ads. They don't know yet they are wasting their money! Every time I travel out of town I always look in the Yellow Pages for well-known photographers that I know are in that area, and rarely do I see anything larger than a one-line listing. My experience with the Yellow Pages is that it attracts shoppers whose main concern is price. Don't waste your money on a large ad.

MARKETING TO HIGH SCHOOL SENIORS

Mailers. Most of the mailers we send out are for high school seniors. Generally we send seven or eight different promotions a year.

To identify target customers, we used to buy mailing lists containing the names and addresses of high school seniors from companies that advertise in photography trade magazines like *Rangefinder, Professional Photographer* (published by PPA), and *Studio Photography*. While at one point, the lists seemed to be about 85 to 90 percent accurate, we purchased one in 2004 that contained about 3500 names and addresses and was only about 38 percent accurate! When we received the list from the company, we had no idea how bad it was. It wasn't until we compared it against lists obtained from local high schools that we found the errors.

Most of the mailers we send out are for high school seniors. Generally we send seven or eight different promotions a year.

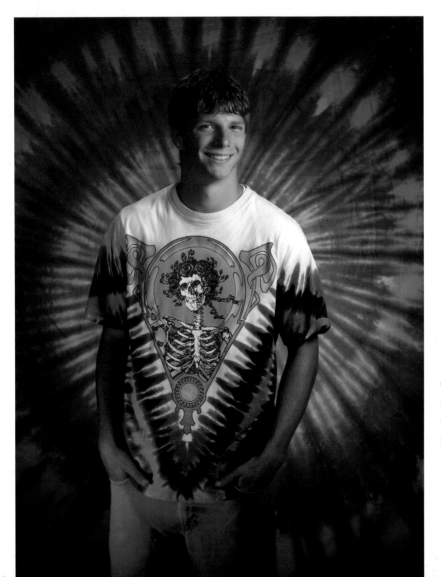

Obtaining mailing lists makes it easy to reach local high-school juniors who will soon be in the market for a senior portrait photographer.

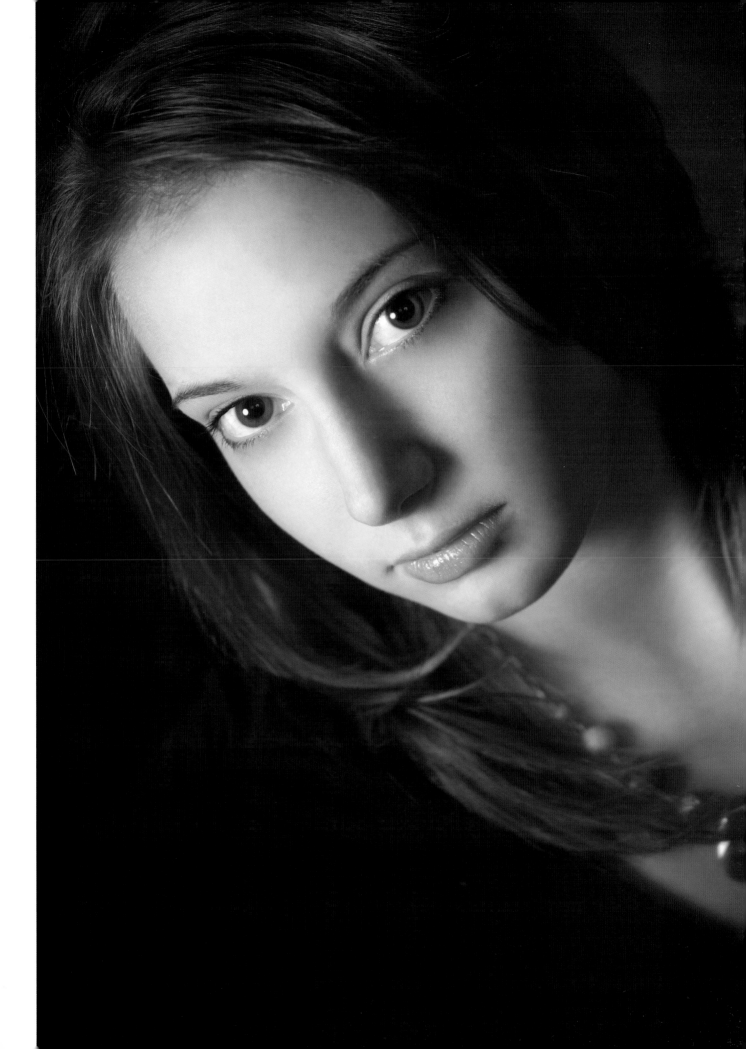

Wall Portrait Packages

Wall Portrait Size	Economy Finish	Deluxe Finish	Canvas Finish	Hand-Painted Brush Stroke On Canvas
30 x 40	$879.00	$969.00	$1110.00	$1359.00
24 x 30	$739.00	$785.00	$910.00	$1110.00
20 x 24	$629.00	$659.00	$759.00	$905.00
16 x 20	$479.00	$519.00	$605.00	$759.00
11 x 14	$399.00	$429.00	$469.00	$550.00

All wall portrait packages include:
2-8 x 10's, 2-5 x 7's, and 40 Wallets
PLUS *the wall portrait size & finish of your choice.*
Choose From 3 Poses
Wall portrait frames available at discount prices.

Packages Without Wall Portrait

Package A: *Choose from 3 poses*
• 3 - 8 x 10 • 4 - 5 x 7's • 47 - Wallets
Economy Finish *Deluxe Finish*
$515.00 **$569.00**

Package B: *Choose from 2 poses*
• 1 - 8 x 10 • 4 - 5 x 7's • 31 Wallets
Economy Finish *Deluxe Finish*
$359.00 **$399.00**

Package C: *1 Pose only*
• 1 - 8 x 10 • 2 - 5 x 7's • 8 Wallets
Economy Finish *Deluxe Finish*
$189.00 **$215.00**

4 Print Finishes to Choose From...

Hand Painted Brush Stroke on Canvas - Photograph is placed on canvas and mounted to 1/8" masonite, then a hand-painted brush stroke is applied which gives your photograph the look of a beautiful hand-painted portrait. Photograph is then sprayed with a protective lacquer finish.

Canvas - Photographs (11 x 14 and larger) are placed on canvas which is then mounted on 1/8" mount board and sprayed with a protective lacquer finish.

Deluxe - Photographs are given the look of canvas and sprayed with a protective lacquer finish.

Economy - Photographs (11 x 14 and larger) are mounted on 1/8" mount board and sprayed with a protective lacquer finish.

• **FREE** yearbook picture with any package.
 (Yearbook photo without package order - $49.00)
• **FREE** 8 print folio on any order more than $725.00
• **FREE** Senior yearbook album on any order more than $950.00
• 5 x 7's in a package are sold in sets of 2 - from same pose.
• Additional poses available for $25.00 each pose.
• Retouching includes the blending of skin blemishes and the softening of lines under the eyes. Other corrections, such as eyeglass glare and hair out of place, require extra artwork and are charged for on a per print basis.
 Minimum charge - $30.00
• Since eyeglasses sometimes cause glare and distortion in photographs, we recommend that you contact your optometrist who will furnish you with a pair of frames that look just like yours.
• Please allow 6 weeks for delivery of finished prints.

Although it's a challenge, you will have to get a list of students from members of the junior class or from the model search promotion (covered later in this chapter). Knowing a secretary or a student aide who works in the high school office is always a good thing.

Mailing Schedule. Be sure to give yourself about eight weeks' lead time for your promotions. This will give you time to design your brochure and get it ready for mailing. Our first mailing of the calendar year offers a low session fee for seniors who have not yet had their pictures taken, or those who had them taken elsewhere and were not happy with the results. In our area, most high schools require that yearbook pictures be turned in by the end of the calendar year, not the end of the school year. This means that anyone getting their pictures taken in January has missed the yearbook deadline and will not be in the yearbook. Most seniors have

ABOVE AND FACING PAGE—Our Portrait Investment brochure makes it easy for clients to determine the best products and packages for their needs.

Wallet Size Photos
(1 pose only)

144 wallets	$169.00
120 wallets	$152.00
96 wallets	$135.00
72 wallets	$115.00
48 wallets	$ 82.50
32 wallets	$ 63.50
24 wallets	$ 51.00
16 wallets	$ 34.00
8 wallets	$ 22.00

- *Name and year imprinted on wallets in gold, silver or white - $17.00 per pose*

Additional Photographs

Portrait Size	Economy Finish	Deluxe Finish	Canvas Finish	Hand-Painted Brush Stroke On Canvas
30 x 40	$665.00	$725.00	$910.00	$1270.00
24 x 30	$515.00	$579.00	$785.00	$1080.00
20 x 24	$405.00	$459.00	$600.00	$785.00
16 x 20	$245.00	$285.00	$395.00	$545.00
11 x 14	$155.00	$185.00	$275.00	$365.00
8 x 10	$75.00	$90.00	Not Available	
5 x 7	$65.00	$79.00	Not Available	
4 x 5	$54.00	$59.00	Not Available	

What About Purchasing A Folio?

1. Previews are not for sale without a minimum order of $189.00

2. Deluxe folios are included with your previews.

3. As your order size increases the cost of the previews decreases.

Order Size	6 Print Folio	8 Print Folio	12 Print Folio
$189.00 - $365.00	$85.00	$105.00	$120.00
$366.00 - $545.00	$75.00	$85.00	$109.00
$546.00 - $725.00	$60.00	$75.00	$90.00
over $725.00	8 PRINT FOLIO FREE		$25.00

Terms & Conditions

Deposit required on previews removed from studio.

All photographs taken by Williams Photography are subject to copyright laws. Any individual who so violates the law by unlawfully duplicating any part of an order will be subject to prosecution.

ALL BUSINESS BY APPOINTMENT ONLY

MasterCard • VISA • Discover • American Express Accepted

already been photographed, so this is one of our least effective promotions. However, since the first three months of the year are the off season, it is still a worthwhile promotion.

Great Model Search. Toward the end of January each year, we mail out our next direct-mail piece. The Great Model Search mailer goes out to high-school juniors. To get their names, we buy only one mailing list, because we know from past experience that the list will be only about 40 percent accurate.

Our mailer informs students about the Great Model Search promotion, a program that offers clear benefits for the students and our studio alike. Here's how it works: interested students call the studio and make an appointment to learn more about the program. Putting the ball in their court is advantageous for two reasons: First, it is hard to reach a junior by

YOU'VE WAITED A LONG TIME FOR YOUR
SENIOR PICTURES
CHOOSE YOUR PHOTOGRAPHER WITH CARE

Bring this certificate the day of your session and receive
75% OFF the session of your choice ($64 value) &
16 FREE wallets ($39 value) when you place your order.
Total Savings $103!!

The Senior Model at your school is: _____

 James **Williams Photography**

1101 Prentice Road • Warren, OH 44483
Phone: (330) 847-0927 • 1 800-320-9005
www.jwilliamsphoto.com

Please send me information about Senior Pictures.

Name _____

Address _____

City, State, Zip Code _____

School _____

Phone Number _____

James **Williams Photography**
1101 Prentice Road
Warren, Ohio 44481

phone after school. Second, when you call, many parents will think you are a telemarketer, and they really won't want to hear what you have to say.

When the students call, we tell them what the program entails and what is expected of them. In a nutshell, the students get a free session and are expected to provide the names and addresses of their classmates, plus drum up business by showing off their pictures and handing out marketing materials. We tell them that this is no giveaway program—they will be expected to produce results and will be well rewarded. If they are still interested, we set up a meeting with them and one of their parents at the studio to further explain everything. It is very important to have a parent attend the meeting with the student. I would suggest having no more than three students and parents attend your meeting at one time.

FACING PAGE—Senior models get a free session in exchange for helping to promote our studio to their friends and classmates.

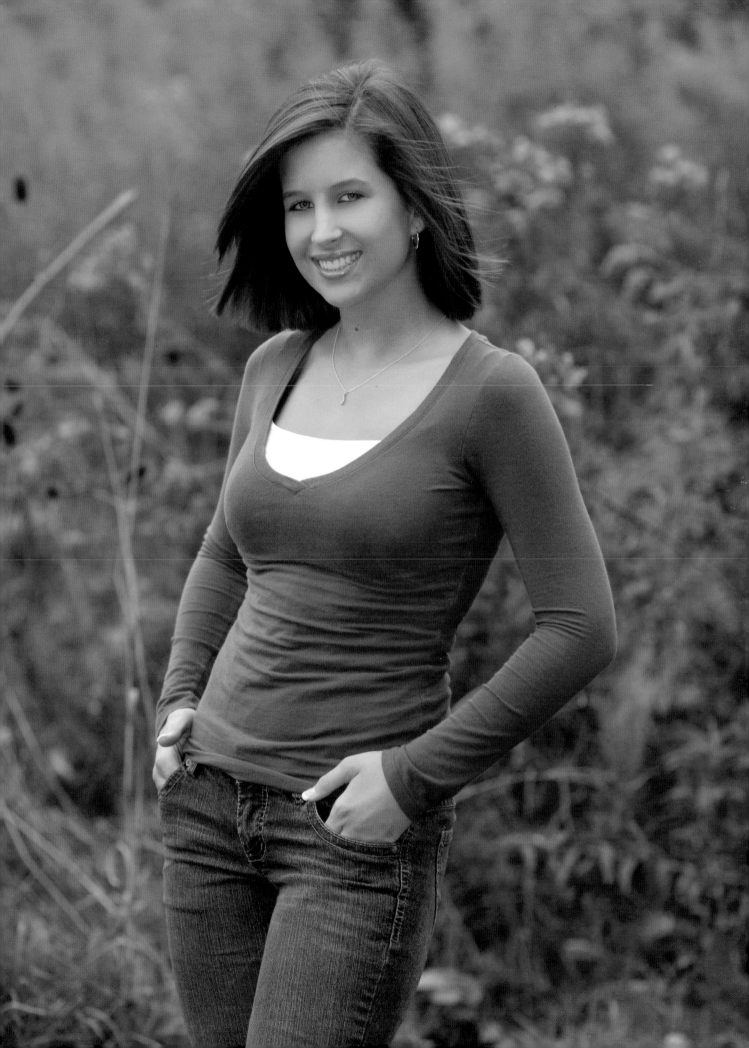

During the meeting, we explain in detail what is expected of them and the rewards they will receive. Everything we tell them is also provided in writing in a senior model handbook that they receive. Most problems that arise are due to misinformation, so your handbook should be clearly worded to minimize any misunderstandings. After the presentation, we ask each student if they would like to sign up—and most of the students who attend the meeting do sign on to become a senior model.

After the meeting, we set up a time for their photography session and remind them, again, that we need names and addresses of their classmates. When they come in for their photography session, we give them a lot of variety.

A week to ten days after the photo shoot, we set up an appointment for the client to come in and pick up the folio and marketing materials that they will be passing out at school.

There are three main benefits to running this program:

ABOVE AND FACING PAGE—Senior models will be proud to show off engaging portraits that make them look great!

Unique images that make a big impression can help attract seniors—who are always looking for something different—to your business.

1. Early sessions for the studio. Our models get a free session, but they pay a hefty deposit to take their photographs out of the studio. This creates cash flow in late winter and early spring—typically a slow time of the year for studios. One word of caution here: you will find that about 10 percent of your models will not come in and put a deposit down on their model folio. Last year we had about thirty models, and three of them never came in to get their final folio pictures. They responded to the model flyer, attended the meeting with their parents, came in for the photo session, and came in to look at their session photos and pick out the photographs for the folio. When it came time to fork over the cash, you guessed it, they were no shows. If you look at our overall results—twenty-seven models times a $350 deposit—you'll have to agree that we had a very good return on the promotion.

Our models get a free session, but they pay a hefty deposit to take their photographs out of the studio.

We have our senior models give their friends promotional cards that entitle students to a discount-price photo session and sixteen free wallets.

2. The models show their folio to all of their friends. We have our senior models give their friends promotional cards that entitle students to a discount-price photo session and sixteen free wallets. For each senior who comes in with the card, the model receives a $20 credit toward their final order. The studio gets new clients, the models receive a $20 credit for each card turned in with their name on it, and the senior turning in the card gets 75 percent off their session fee, plus sixteen free wallets when they place their final order. Everyone wins.

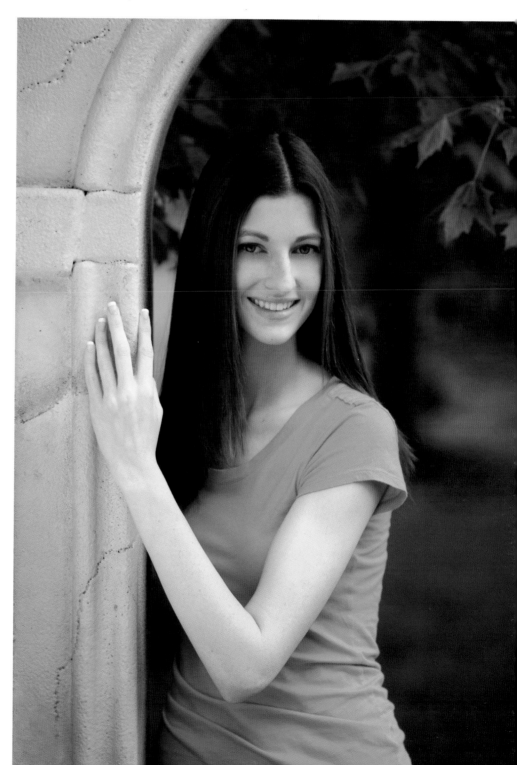

The Great Model Search promotion benefits everyone involved—the studio, the model, and everyone the model refers.

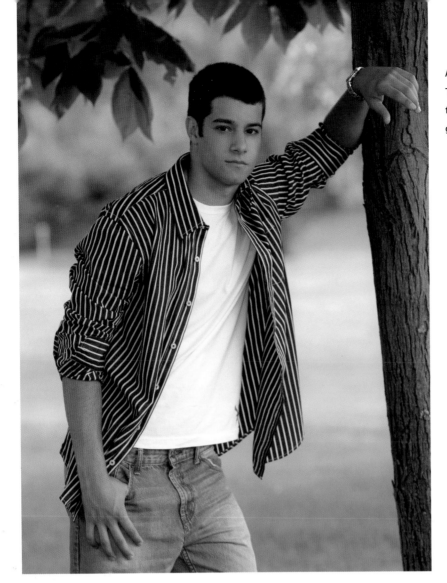

A relaxed natural pose always looks good. This is the kind of image guys won't hesitate to share with their friends (moms and girlfriends love them, too).

3. The new models obtain the names and addresses of their classmates. This is probably the most important function of the new models each year. Without accurate contact information, it's difficult to run an effective advertising campaign.

Many studios let the senior models take the pictures out of the studio without securing a deposit. I can tell you for certain that, if you do, some students will never return them. I don't care what kind of incentives you have, some people just have no respect for your product. I hate to sound negative, but that's the way it is. We require our models to pay a $350 deposit when they take out their promotional photographs. This is fully understood during the meeting they attend. I suspect that may be why a few people back out of the program after they attend the meeting. When the models return their proofs later in the year, however, the full $350

Without accurate contact information, it's difficult to run an effective advertising campaign.

deposit goes toward their purchase—but if we never see them again, at least we have some money from them. Don't feel bad if you have a few models who never return their pictures. Anyone using models or ambassadors is going to have students who do not return the folio. This is why it's important to get a hefty deposit from each model beforehand.

Twelve-Hour Sale. Another promotion that works well is a twelve-hour sale. Although there are other studios using this promotion in our area, it is still a very effective way to book a lot of seniors in one day. The one-day-only sale creates a sense of urgency for the client to call on the

The one-day-only sale creates a sense of urgency for the client to call. . . .

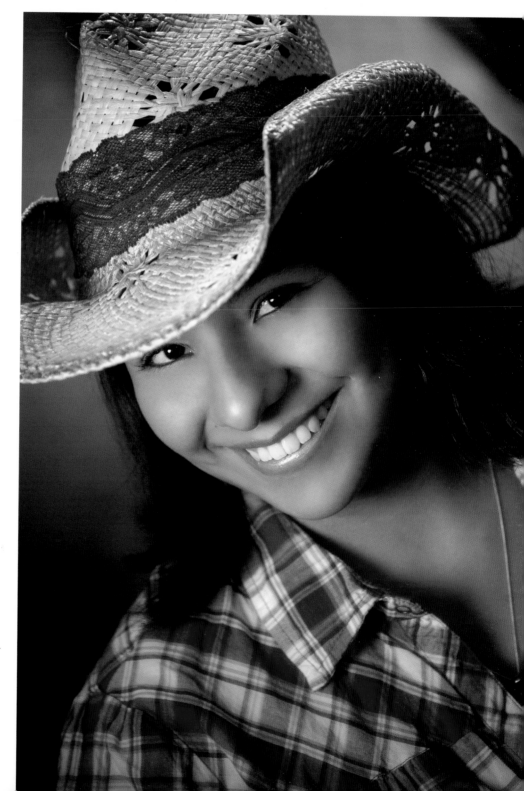

A great smile creates a great image.

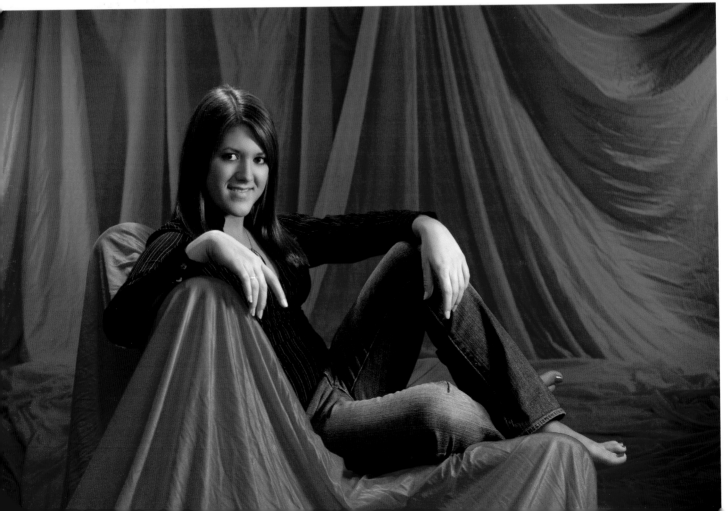

ABOVE AND FACING PAGE—Offering a limited time offer is an effective way to fill your calendar with portrait sessions.

By the end of this promotion, we are into the summer months, which are always very busy for our studio.

sale day. I would suggest mailing it in early to mid-April for a later April sale date. During this half-off sale, we require that all clients prepay for their session. We will take their credit card payment over the phone or give them three to four days to send in their payment. We simply explain that there are a limited number of appointments available and their advance payment guarantees their appointment time.

Discounted Session Fees. In early May, we send out an 8½x11-inch, twelve-page, full-color brochure with an insert inside announcing a discounted-session-fee promotion that runs for about three weeks. We always make it a point to create a sense of urgency. We say, "There are a limited number of appointments available, so call now!" About two weeks later, we send a postcard as a follow-up, extending the offer for another week. By the end of this promotion, we are into the summer months, which are always very busy for our studio.

James **Williams**
Photography

certified professional photographer

1101 Prentice Rd
Warren, Ohio 44481

330 847-0927
1-800-920-3005
www.JWilliamsPhoto.com

Wedding Photography
Investment Brochure

Professional Photographers of America

Complete All Day Coverage of your wedding and reception
$3000.00

The entire $3000.00 fee applies to your photographs and album. If you like, we will design your album for you.

A few words about our photographer:

• Williams is a certified professional photographer at both the state and national level. Williams passed a written exam and entered photographs to a national and state panel of judges for review and approval to become certified. Less than 3% of all imaging professionals have completed and maintained the requirements for certification.

• Willaims is a Wedding Portrait Photographers International Master Photographer.

• Williams is one of only 40 members of the prestigious Ohio Society of Professional Photographers. This organization consists of some of the most talented photographers from across the state. Membership is by invitation only.

• Williams has served as president of the Society of Northern Ohio Professional Photographers, a professional photography organization based out of Cleveland, Ohio.

• Williams teaches photography and is a popular guest lecturer in the mid-west. Currently, Williams is writing a book on photography, due out in book stores early next year.

• Williams Photography has been in business more than 20 years. Be assured whenever you call our studio you will be dealing with professionals who are dedicated to providing you with the highest level of professionalism and expertise available.

Photographs available in 3 different finishes.

Deluxe Texture Finish

4x5's or 5x5's	5x7's	8x10's	1/2 pan	full pan
$28	$30	$36	$105	$200

Texture Finish

4x5's or 5x5's	5x7's	8x10's	1/2 pan	full pan
$24	$28	$34	$90	$175

Standard Finish

4x5's or 5x5's	5x7's	8x10's	1/2 pan	full pan
$20	$25	$32	$80	$160

Wall Portraits

Print Size	Hand-Painted Brush Stroke On Canvas	Canvas Finish	Deluxe Finish
11x14	$300	$225	$150
16x20	$450	$325	$235
20x24	$650	$500	$375
24x30	$875	$650	$475
30x40	$1050	$750	$600

Wedding Albums

Finest Hand Bound Leather Album
All leather and hand crafted. All of your photographs receive our deluxe/texture finish, then they are mounted to each page by hand. You will be proud to show this all leather top-of-the line wedding album to your family and friends. $725.00

Deluxe Album
This deluxe vinyl album has the look and feel of leather. A very upscale album. Available in a variety of colors. $595.00

Standard Album
A lovely album for your wedding memories. Although not book bound, this album is a beautiful addition to your photographs. $350.00

Economy Album
A Vinyl Album for your wedding photographs. $275.00

Parent Albums $210.00

please note: prices are for album covers and pages only, photographs are not included.

FACING PAGE—Our Wedding Investment brochure presents our prices along with a list of reasons why our services are worth investing in.

By starting your promotions early in the year you have given yourself a much better chance of filling up the summer with sessions. Frequent mailing is almost a must if you want to do more than two or three hundred senior sessions a season.

High-School Newspapers and Yearbooks. Advertising in the local high-school yearbooks is something you almost have to do if you are photographing high-school seniors. Placing an ad in the yearbook is really not an effective form of advertising, though. I consider it a donation to the high school. I would suggest getting at least a half-page ad and featuring pictures of seniors from the school who came to you for their portraits. Students love to have their pictures in the yearbook as many times as possible. Another idea for your ad is to have testimonials from the students under their pictures.

Advertising in high-school newspapers, usually monthly publications, works fairly well. We have successfully run ads with pictures and testimonials in some of our area high-school papers. Every year we are also asked to run ads in soccer, football, and basketball programs. Like the yearbook ad, this is seen more as a donation. We always agree to run the ads, but we really don't expect any return on our investment.

MARKETING TO WEDDING CLIENTS

As you probably know by now, we operate a higher-end studio and emphasize service and quality. Where you market and the personality of your studio will determine, to a large degree, the type of bridal clientele you are going to attract. The fact is, there are weddings every week at fire halls and country clubs, but there are a whole lot more fire-hall weddings than country-club weddings. To attract the high-end bride, you will have to put your advertising dollars in the right place. Advertising in regional bridal magazines, constructing mall displays, and attending bridal shows are all effective means to attracting higher-end wedding couples. A word of caution: If you are going to participate in a bridal show, be careful which ones you choose. Those bridal shows that charge admission and are held at hotels are usually a good bet. I made the mistake one year of participating in a bridal show in a mall. There was no admission fee, which meant anyone who wanted to kill some time meandered through the show. I did book one bride at that show, but a lot of the girls looking at our samples were just not going to have a big fancy wedding. Brides having their reception at the local fire hall or VFW hall will not spend $5000 dollars on wedding photography, regardless of how good your pictures might look. In fact, the entire wedding probably won't cost that much! There are a vast

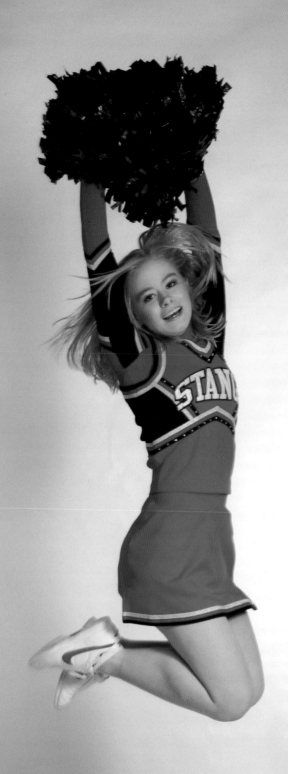

number of photographers who will photograph a wedding for $500 or less. Do not waste your money printing coupons. Brides with discretionary income are not into clipping coupons. Many of these brides are spending their parents' money and really aren't all that concerned with saving a few bucks. Their thinking is, this is my big day, and I want the very best.

Once you begin working with your desired client type and provide the type of product and service a high-end client demands, word of mouth will be your best source of advertising.

MARKETING TO SPORTS LEAGUES

All of our league jobs have resulted from interacting with someone who had come to the studio for another type of photography—and just happened to be president of a soccer league, or something to that effect. I know I probably sound like a broken record, but the fact is, when a studio is doing everything right, a lot things just fall into place.

You won't acquire a sports league contract through direct-mail advertising. If you haven't made the right contacts, try these ideas to increase your chances of scoring a sports league contract:

- If you have a mall display, put up some samples of your league work. There's always a chance that a league president in need of a new photographer will see it and make contact.
- Read your local newspapers daily. Usually there are listings in the local paper telling the parents where sign-ups for

baseball, soccer, football, etc., are held. Prepare a first-class presentation packet with photo samples, prices, etc., and on sign-up day, give it to the president of the league. If he had a lot of problems with last year's photographer, he may be looking for a new studio.

Remember, the last thing volunteers want is problems from the parents. If no one is complaining about the pictures from the league's current photographer, chances are you won't be hired. It doesn't take much to make these people happy.

Many people who pay $15 to $20 for a memory mate package for their child would never think of spending over $1000 on a family portrait. They simply do not have the discretionary income that some folks will spend on higher-end photo packages. You have to have an entirely different mindset when dealing with leagues than you do with clients in the studio who are willing to spend thousands of dollars on a portrait order. These clients are looking for decent images with good expressions—not all of the bells and whistles you might offer to bigger-budget clients.

Most of our family portrait business comes from the high-school seniors we photograph.

MARKETING TO FAMILIES

Most of our family portrait business comes from the high-school seniors we photograph. We offer a free family portrait certificate to all our high-school senior clients when they pick up their final order and place a follow-up call to the client to remind them of the free session a few months later. To be perfectly honest, only five to ten clients take advantage of the certificate each year.

All of our senior portrait clients receive coupons for a free family portrait session.

Family Portrait Investment

Hand-Painted Brush Stroke on Canvas - *Photograph is place on canvas and mounted to 1/8" masonite, then a hand-painted brush stroke is applied which gives your photograph a look of a beautiful hand-painted portrait. Photograph is then sprayed with a protective lacquer finish.*

30 x 40	$1270.00	24 x 30	$1080.00
20 x 24	$ 785.00	16 x 20	$ 545.00
11 x 14	$ 365.00		

Canvas Print - *Photograph is placed on canvas which is then mounted on 1/8" mount board. Photograph is then sprayed with a protective lacquer finish.*

30 x 40	$910.00	24 x 30	$785.00
20 x 24	$600.00	16 x 20	$395.00
11 x 14	$275.00		

Deluxe Print - *Photograph is given the look of canvas and sprayed with a protective lacquer finish.*

30 x 40	$725.00	24 x 30	$579.00
20 x 24	$459.00	16 x 20	$285.00
11 x 14	$185.00		

Standard Print - *Photograph is mounted on 1/8" mount board and is sprayed with a protective lacquer finish.*

30 x 40	$665.00	24 x 30	$515.00
20 x 24	$405.00	16 x 20	$245.00
11 x 14	$155.00		

Large Selection of Beautiful Wood Frames Available!

Small Prints

	Economy	Deluxe
8 x 10's	$75.00	$90.00
5 x 7's	$65.00	$79.00
4 x 5's	$54.00	$59.00

Wallet Size Photos

16 wallets	$34.00
8 wallets	$22.00

Family Portrait Session Fees

in studio - $85.00
in your home - $100.00

Terms & Conditions

- All finished prints have been analyzed & color corrected to ensure a beautiful portrait.

- Retouching includes the blending of skin blemishes and the softening of lines under eyes. Other corrections, such as eye glass glare and hair out of place, require extra artwork and are charged for on a per print basis. Minimum charge - $30.00.

- Since eyeglasses sometimes cause glare and distortion in photographs, we recommend that you contact your optometrist who will furnish you with a pair of frames that look just like yours.

- Please allow 6 weeks for delivery of finished prints.

- All photographs taken by Williams Photography are subject to copy right laws. Any individual who so violates the law by unlawfully duplicating any part of an order will be subject to prosecution.

Our Family Portrait Investment brochure details the available products and the terms and conditions of the sale.

We also have family portraits displayed in the studio and include family portraits in our mall display to create interest. You can also use direct mail to draw new family portrait clients. Just purchase a mailing list from an address broker and qualify it by income level. I would suggest sending the mailers to families making more than $50,000 a year. The fall of the year is a good time to send out marketing materials announcing a promotion for family portraits. Chances are, you will receive some calls from clients who want you to come into their homes to create holiday portraits.

9. NETWORKING

Anyone who wants to fast-forward their photography career needs to join their local and state photography affiliations. Most of the state-run organizations have several programs and one major convention a year, while the local groups meet once a month. Attending the state and national conventions, such as the Professional Photographers of America (PPA) and Wedding Portrait Photographers International (WPPI) conventions, is always fun. These include a large trade show and many good speakers. You will leave these shows all charged up and ready to try out the new tools you have purchased or tricks you have learned.

Joining a local affiliate of PPA will give you the opportunity to hear speakers monthly and network with people who have been in the business for years. Although you may have to drive a distance, I think you will find the time well spent. The closest affiliate for me is the Society of Northern Ohio of Professional Photographers (SONOPP), based in Cleveland, Ohio. It is about a one-hour drive from where I am located in Warren, Ohio. Joining SONOPP has definitely impacted my business in a very positive way. The state of Ohio and the Cleveland area in particular have some extremely talented photographers with successful businesses. There is just no way you can learn everything yourself. The more you get involved, the more you will benefit.

Attending week-long schools or even two- or three-day seminars will pay big dividends throughout the year.

Photography is always changing, and keeping current is essential if you want to continue or improve your success. Attending week-long schools or even two- or three-day seminars will pay big dividends throughout the year. There are many talented business and photography speakers. Personally, I enjoy listening to the marketing- and businesspeople. You might even want to consider attending marketing and business programs that are not put on by photographers. After all, good marketing is essential to your success.

Networking with associations outside of photography is also a great way to meet new people and cultivate your business. Also, working with your fellow vendors such as catering halls and florists can be beneficial. To make the most of these relationships, consider this tip: If you get to the catering hall before the wedding guests, take some photographs of the entire hall, the table settings, decorations, etc. Print some 8 x 10-inch images and give them to the caterer in a couple of weeks. Now he has some

professional photographs to show new clients and, in all probability, he will remember who gave him the pictures. Do the same with the florist. Take some close-ups of the flowers at both the reception and the church and send them to the florist. It's all the little things you do that will ensure your success.

Your local Rotary, Lions, and Kiwanis clubs are excellent organizations to get involved with, not only for business contacts but just because they do good things for the community. Often, the school superintendent or principal attends meetings at the local service clubs, so this can make for a great networking opportunity. Remember, you are in the image business—both literally and figuratively.

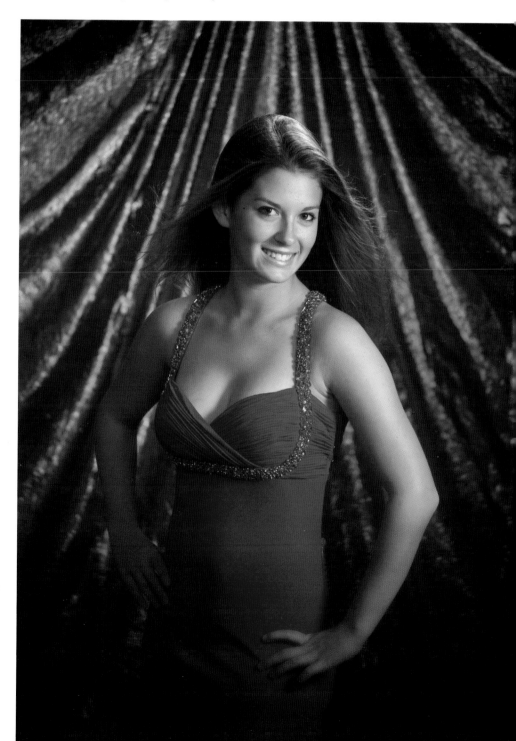

I aimed a wind machine at the subject's hair to add flair to this picture.

10. SUMMING IT ALL UP

Unfortunately, the world is filled with people who don't like their jobs. There may be a few exceptions to what I'm about to say, but I think most people would agree with the following: anyone who is truly successful at what they do for a living probably loves what they do everyday. When you are doing something you truly enjoy, you naturally will do a better job.

Photography is not an easy business to make a living in. The need to wear so many different hats—creative artist, top-notch marketer, practical businessperson—makes it even more difficult. But if you really enjoy photography and can surround yourself with some really good people, you will more than likely succeed. Be optimistic and listen to positive people. Spend time in the company of people who are where you want to be in life.

When you are doing something you enjoy each day, you will be a much happier person, and your happiness will be very apparent to your clients, employees, family, and friends. I'm not telling you that every day is a holiday in this business. Just like any other business, you are going to have problems. Finding solutions to the problems and meeting the challenges successful will ensure your success.

When you are doing something you enjoy each day, you will be a much happier person . . .

The really cool thing about the photography business is that, for the most part, you are around people when they look their very best. They have called you because they want you to create an image of them to share with their family and friends. They have put their trust in you. When they are thrilled with their images and give you a sizeable order for your talent, it is very rewarding.

GOOD PEOPLE SKILLS ARE A MUST

Good people skills are important in many jobs, but particularly in photography. When a client has called you for an appointment, they are expecting a photograph that they are really going to like. The best photograph of someone is usually one where the subject looks relaxed and natural and has a great expression on his face (remember: ESP—Expression Sells Portraits!). Engaging the client in relaxing conversation about their interests is a great step toward creating a portrait they are going to be happy with. However, the only way that is going to happen in the photography session

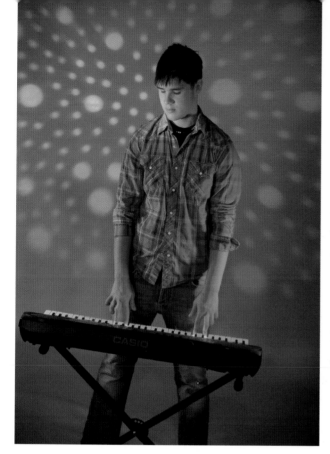

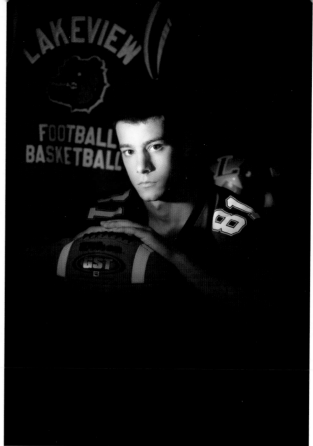

LEFT—Blue and orange gels on the subject and a theater pattern in a projection box was used to create this high school senior portrait. **RIGHT**—Very controlled lighting was used here.

is through your excellent people skills. This is something I believe is truly a natural talent. I don't think you can teach someone how to be a good communicator and listener—but if you are naturally comfortable talking with all types of people, you are well on your way to creating images that your clients will love.

IF IT WERE EASY, EVERYONE WOULD BE DOING IT

Okay . . . maybe what I should say is, "If it were easy, every studio owner's business would be profitable." Unfortunately, according to the Professional Photographers of America, approximately 30 percent of all studios never make a profit. This doesn't even account for all of the part-timers who do not rely on photography for their livelihood. They are happy if they make a few extra bucks on the weekends.

This is not an easy business in which to make a living (we have all heard the phrase "starving artist"). However, there are also studios out there that are doing extremely well, but this takes a lot of work and a lot of time. Rome wasn't built in a day! It takes several years for any kind of business to be successful. It also takes work by someone who recognizes that success has very little to do with taking beautiful pictures. If you only remember one piece of information from this book, that's the phrase to keep in mind.

The major reason so many photographers are struggling is that they focus their time and energy exclusively on the photography portion of the business and mostly ignore the business and marketing components. I have visited studios in my state that have extremely profitable operations and not one single trophy or ribbon from print competition. On the other hand, I know people who have just about every award you can get in photography and have hardly any clients. Don't misunderstand what I'm trying to say: doing what it takes to win blue ribbons and trophies will definitely make your photography better, but it certainly will not guarantee financial success. Awards are a very small piece of the success pie. To your clients, you are only as good as your last portrait session.

You must have a blend of skills if you are going to make a living in photography. Some of the information you need to succeed is found in this text. Be fair with yourself—develop a business plan, work the plan, and plan to work. Strive to learn from other photographers whose practices and work you admire. Set both short- and long-term goals and expect some failures along the way. Don't get discouraged, and always learn from your mistakes. Owning a successful photography studio is very rewarding. People come to you because they trust your skills and talents; they don't want to just look good in their photographs, they want to look really good—and they have called you for the job. Practice your craft, keep a keen eye on business and marketing, surround yourself with excellent employees, and you will be on your way to being successful—in any market!

A fish-eye lens was used to create the curved effect shown here.

Albums Inc. (albums, frames, folios, etc.)
15900 Foltz Industrial Parkway
Strongsville, Ohio 44149
(800) 662-1000

Blossom Publishing Company (color brochures and cards)
163 E. Second Street
Winona, Minnesota 55987
(507) 474-7450

Flash Point Studios (voice talent for phone systems)
www.flashpointstudios.com
(877) 352-7478

Hal Mar Printing (all printed materials except color brochure)
155 North Street N.W.
Warren, Ohio 44483
(330) 399-5034

The Image Place Photo Lab
3520 Pennsylvania Ave.
Weirton, West Virginia, 26062
(304) 723-3085

Response Mail (large mailing envelopes for marketing)
4517 George Road
Tampa, Florida 33634
(800) 795-2773

SKP Photo Lab
8250 Tyler Blvd., Unit A
Mentor, Ohio 44060
(440) 205-0221

INDEX

OTHER BOOKS FROM

Amherst Media®

Master Guide for Team Sports Photography

James Williams

Learn how adding team sports photography to your repertoire can help you meet your financial goals. Includes technical, artistic, organizational, and business strategies. *$34.95 list, 8.5x11, 128p, 120 color photos, index, order no. 1850.*

JEFF SMITH'S

Posing Techniques for Location Portrait Photography

Use architectural and natural elements to support the pose, maximize the flow of the session, and create refined, artful poses for individual subjects and groups—indoors or out. *$34.95 list, 8.5x11, 128p, 150 color photos, index, order no. 1851.*

WES KRONINGER'S

Lighting Design Techniques

FOR DIGITAL PHOTOGRAPHERS

Design portrait lighting setups that blur the lines between fashion, editorial, and traditional portrait styles. *$34.95 list, 8.5x11, 128p, 80 color images, 60 diagrams, index, order no. 1930.*

CHRISTOPHER GREY'S

Lighting Techniques for Beauty and Glamour Photography

Create evocative, detailed shots that emphasize your subject's beauty. Grey presents twenty-six varied approaches to classic, elegant, and edgy lighting. *$34.95 list, 8.5x11, 128p, 170 color images, 30 diagrams, index, order no. 1924.*

UNLEASHING THE RAW POWER OF

Adobe® Camera Raw®

Mark Chen

Digital guru Mark Chen teaches you how to perfect your files for unpreceented results. *$34.95 list, 8.5x11, 128p, 100 color images, 100 screen shots, index, order no. 1925.*

BRETT FLORENS'

Guide to Photographing Weddings

Brett Florens travels the world to shoot weddings for his discerning clients. In this book, you'll learn the artistic and business strategies he uses to remain at the top of his field. *$34.95 list, 8.5x11, 128p, 250 color images, index, order no. 1926.*

Advanced Wedding Photojournalism

Tracy Dorr

Tracy Dorr charts a path to a new creative mind-set, showing you how to get better tuned in to a wedding's events and participants so you're poised to capture outstanding, emotional images. *$34.95 list, 8.5x11, 128p, 200 color images, index, order no. 1915.*

Corrective Lighting, Posing & Retouching

FOR DIGITAL PORTRAIT PHOTOGRAPHERS, 3RD ED.

Jeff Smith

Address your subject's perceived physical flaws in the camera room and in postproduction to boost client confidence and sales. *$34.95 list, 8.5x11, 128p, 180 color images, index, order no. 1916.*